IMAGES
of America

FLORIDA'S
SPACE COAST

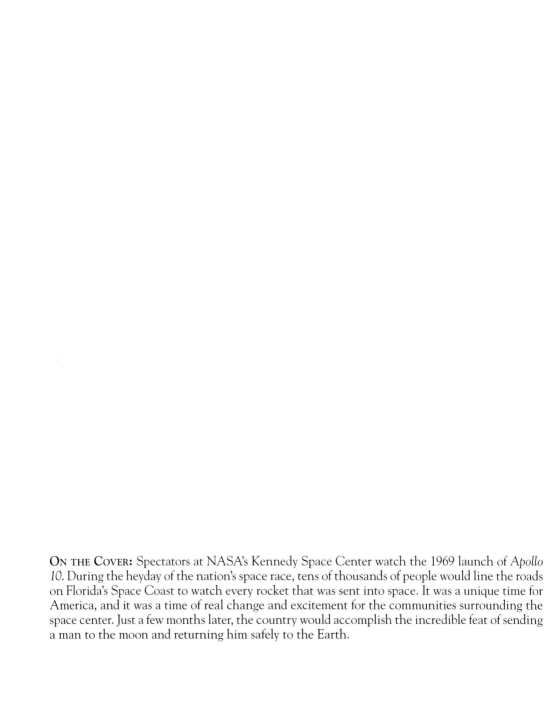

ON THE COVER: Spectators at NASA's Kennedy Space Center watch the 1969 launch of *Apollo 10*. During the heyday of the nation's space race, tens of thousands of people would line the roads on Florida's Space Coast to watch every rocket that was sent into space. It was a unique time for America, and it was a time of real change and excitement for the communities surrounding the space center. Just a few months later, the country would accomplish the incredible feat of sending a man to the moon and returning him safely to the Earth.

Images of America
Florida's Space Coast

Wade Arnold
Foreword by Astronaut Andy Allen

Copyright © 2009 by Wade Arnold
ISBN 978-0-7385-6624-5

Published by Arcadia Publishing
Charleston SC, Chicago IL, Portsmouth NH, San Francisco CA

Printed in the United States of America

Library of Congress Control Number: 2009925984

For all general information contact Arcadia Publishing at:
Telephone 843-853-2070
Fax 843-853-0044
E-mail sales@arcadiapublishing.com
For customer service and orders:
Toll-Free 1-888-313-2665

Visit us on the Internet at www.arcadiapublishing.com

This book is dedicated to all those who have lost their lives in the pursuit of space exploration and to my family, whose support made all the difference.

Contents

Foreword		6
Acknowledgments		7
Introduction		8
1.	Cocoa Beach	9
2.	Cocoa	45
3.	Cape Canaveral	59
4.	Melbourne	65
5.	Merritt Island	71
6.	Patrick Air Force Base	79
7.	The Space Race	87

Foreword

By the time I lifted off aboard the Space Shuttle *Atlantis* in 1992, it had been 23 years since men first walked on the moon. In 1969, I was 14 years old when *Apollo 11* astronauts Neil Armstrong and Buzz Aldrin climbed out of their small lunar module and stepped onto the moon's surface. It was probably the most famous walk ever seen on television, and like so many around the world, I was inspired by what my country had accomplished.

The Apollo missions ended in 1972, but the impression on my life was set. I would eventually have the honor of serving my country in the U.S. Marine Corps and be honored once again when I was selected to join NASA in 1987. I had flown over 6,000 hours in the Marines and, as an astronaut, would eventually log hundreds of hours in space. Today, looking back on my experiences with the benefit of time, I realize I'm still inspired by those early heroes.

The space program had gone from launching small V-2 rockets out of Cape Canaveral to putting men on the moon, all in the span of a few years. The Mercury, Gemini, and Apollo astronauts accomplished what some thought was just a dream, and they changed the world while they were at it. For people in communities like Florida's Space Coast, that change was instantly part of their lives.

It's important for us to remember those who went before us. The pictures in this book tell a story about a time in our history when a few people put everything on the line to achieve the impossible, and thousands of people supported them to make it happen. What they accomplished in our past gives me great hope for our future; I hope you can be inspired, too.

—Lt. Col. Andy Allen
March 31, 2009

ACKNOWLEDGMENTS

This book would not have been possible without the help of many people who care about history, and their help was greatly appreciated by the author. A heartfelt thank-you goes to the Florida Historical Society and all its staff and volunteers, the staff of the Historic Rossetter House Museum, City of Cocoa Beach city clerk Loredana Kalaghchy and her staff, the Cocoa Beach Library, the U.S. Air Force, NASA, and the Kennedy Space Center director's office, the staff of the *Florida Today* newspaper, and to everyone else who played a part in the making of this book. Unless otherwise noted, all images are courtesy of the Florida Historical Society, the City of Cocoa Beach, Pete Godke, NASA, or the U.S. Air Force.

INTRODUCTION

Florida's Space Coast is the nickname given to an area of Florida that had a quiet, beach-town atmosphere until the space race of the late 1950s sent its population soaring like a rocket. The beach attitude still remains to this day, but the communities in Brevard County, along some 70-plus miles of Atlantic Ocean coastline, were changed forever during that era.

Some of the communities in this book, like Cocoa and Melbourne, had hundreds of residents as far back as the 1800s, while others, like Cocoa Beach, had less than 50 people in 1940. They all would change dramatically after the National Aeronautics and Space Administration (NASA) was formed in 1958. Eight years earlier, in 1950, a modified V-2 rocket was launched from Cape Canaveral, Florida. Few could have predicted that the launch would signal a coming wave of change.

Although there is evidence that Ponce de Leon actually discovered Brevard County, it was not until 1828 that it was established by the Territory of Florida. They called it Mosquito County. Its name would change several times over the years, and in 1854 it took on the name Brevard. Early residents were involved in the citrus trade, sugar cane crops, and even some cattle raising. Those early days were difficult, not only because of the terrain but because of hostile Native Americans. The Eau Gallie area, now part of Melbourne, was established in 1874, and the first jail was built to the north, in Titusville, in 1876. A railroad that came to the county helped to create economic growth.

By the 1920s, residents built a bridge expanding to the beaches of Cape Canaveral and Cocoa Beach, but most supplies and even the mail were still delivered to many by boat. The entire county was still a rural area and mainly viewed as a nice vacation spot to those from out of town. Merritt Island, located between Cocoa to the west and Cocoa Beach to the east, had almost no one in it at all. One future Space Coast resident, Paul Godke, traveled through the area in 1932. He was looking for Cocoa Beach and reportedly missed the town altogether. A few years later, he would move his wife and two sons there to help run a hotel.

The Godke family's experiences were typical for the area. They lived in a quiet community whose most exciting stories were probably those of World War II. Located just south of Cocoa Beach, the Banana River Naval Air Station was formed in 1940, and beach residents actually helped sailors whose ships were sunk by German U-boats. In 1947, the air station became Patrick Air Force Base, and in 1950 rockets began to light up the skies of Brevard County.

In 1961, Pres. John F. Kennedy gave the country a challenge. The nation would send a man to the moon and return him safely to Earth by the end of the decade. The space race kicked into high gear. The government bought 88,000 acres of land on Merritt Island for its space program, and the workers started coming to Florida.

It is told in stories that the county growth during the space race was so fast, some families were forced to sleep in cars or in large concrete drainage pipes. Everyone was affected by the surge of people. Although some cities already had infrastructure like schools, hospitals, and churches, it was not enough. Others, like Cocoa Beach and Cape Canaveral, had to plan from scratch. During those early days, residents formed the core of what their communities would become. Early pictures of the communities surrounding Kennedy Space Center show how rural residents moved into a modern age. Somehow, through perseverance, hard work, and probably a little luck, they were able to maintain their small-town feel.

The last piece of the puzzle, or possibly the first, depending on how you look at it, was the space program itself. The pictures of those involved in the space program show people who took on a great task with a great amount of risk. There was a drive for the country to be the best at something, and some men put their lives at stake to make it happen. It was written later by author Tom Wolfe that those men had the "right stuff," and history shows us he was right. What they did changed the country forever, and it gave a community the name of Florida's Space Coast.

One
Cocoa Beach

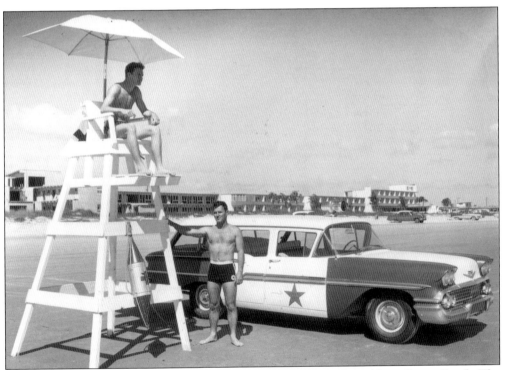

This 1960s photograph shows lifeguards watching for swimmers in trouble in Cocoa Beach. The fact that lifeguards were even needed on the beach is a real sign of how popular the area had become with the onset of the space race.

These undated photographs show that there really were pioneer settlers in Brevard County before anyone thought of sending a man to the moon. Early settlers to the area named it Mosquito County in 1828, and it is not hard to guess why. But the earliest discovery known, according to some historians, was by Spanish explorer Ponce de Leon in Melbourne Beach. On March 14, 1844, the area was established as the state of Florida's 25th county. Over the next three decades, the name and size of the county would change until finally taking on the name it uses today.

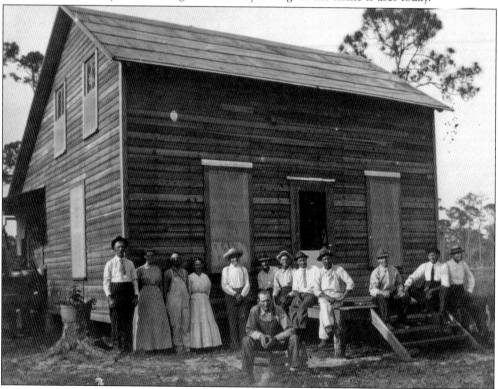

The City of Cocoa Beach was incorporated in 1925. Although there was not much in the area, there was a 300-foot-long boardwalk. The wooden structure led up to the Cocoa Beach Casino and four bungalows located at the east end of Minutemen Causeway, right on the Atlantic Ocean. Pictured above are R. E. Grabel and "Papa" James A. Haisten Sr., who were both elected commissioners that same year, along with Gus Edwards (not pictured). The casino would later become the Ocean Lodge. A complete view of the boardwalk and casino are seen in the postcard below. The boardwalk itself was destroyed in a 1926 hurricane.

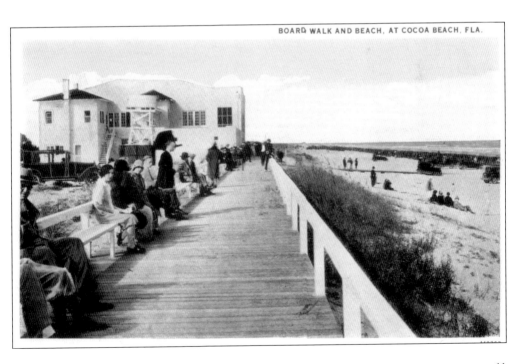

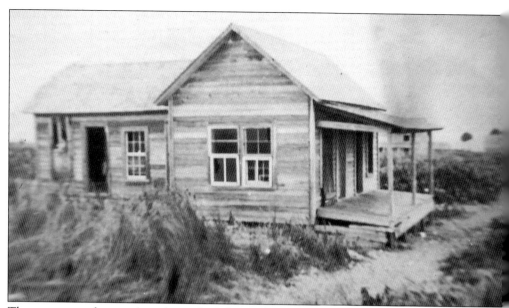

There were very few people and even fewer homes located in Cocoa Beach before the 1950s. This house, built sometime during the 1920s, is reportedly one of the oldest residential houses in Cocoa Beach. Located just west of Highway A1A on Nassau Road, it still exists today.

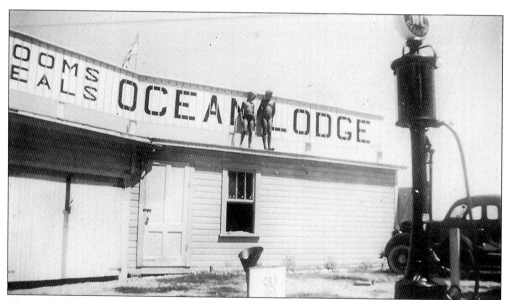

This 1930s photograph shows two adventurous boys from the Godke family playing around at the Ocean Lodge, where the first gas pump was built. Gas prices back then were just 22¢ a gallon. During those early years, the lodge, located right on the beach, was one of the few places available to stay.

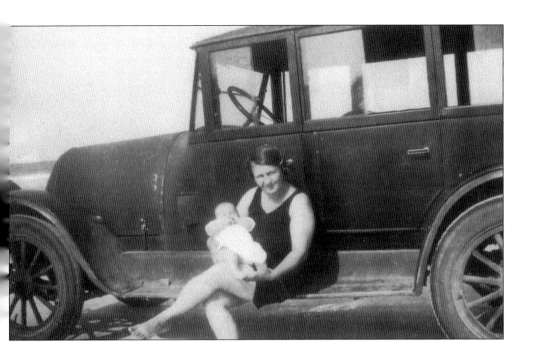

The photograph above shows Esther Kline in May 1929, sitting on a car at Cocoa Beach. If someone could afford a car back then, he or she was more than welcome to drive it on the beach. An advertisement from that time tried to convince people from as far north as Buffalo, New York, that the beach was just "36 hours" away by train. By 1939, though, there were still officially less than 50 residents living in Cocoa Beach. It was big enough, however, to hold the first merchant beach party, as seen in the photograph below. Of note are the number of cars on the beach, and the Coca-Cola brand soda sign located just in view at the bottom of the photograph.

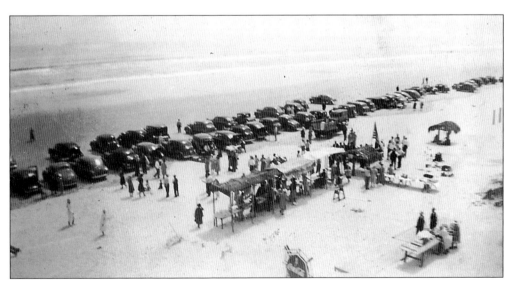

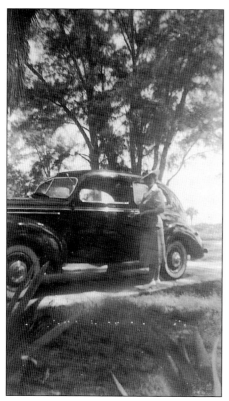

The photograph on the left, probably taken during the late 1930s, shows Ann Godke standing next to her car. The Godke family moved to the area to manage the Ocean Lodge and would eventually open a locally well-known gift shop. The big tree in the background is probably one of many that used to line Orlando Avenue, also known today as Highway A1A. The woman dancing in the undated photograph below is probably also Ann Godke. Compared to today, there probably did not seem to be much entertainment back then, but the beach was a big enough attraction for residents.

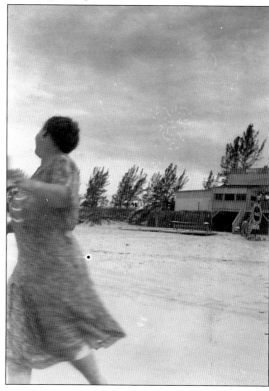

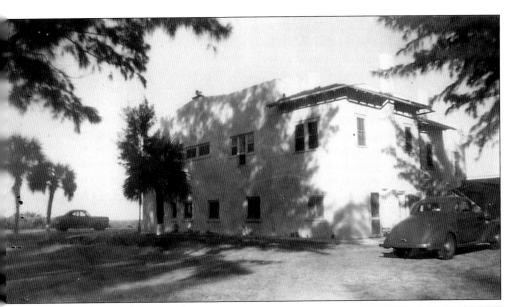

This apartment house, shown in the 1930s, was one of the few places where residents could live after moving to Cocoa Beach. The Godke family first lived here after moving to Cocoa Beach to manage the Ocean Lodge. The family eventually would move into a small house located nearby.

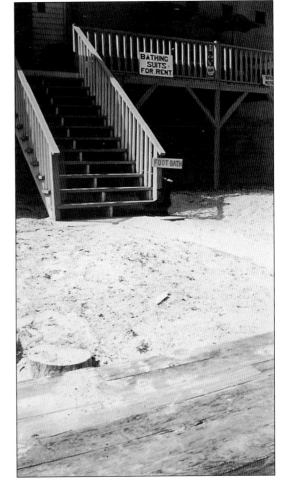

Yes, times were different from today in the 1930s and 1940s, as evident in this photograph looking at an entrance to the Ocean Lodge in Cocoa Beach. Note the sign to the right of the stairs that says, "Bathing suits for rent."

This 1940s photograph shows Atlantic Avenue, which is part of Highway A1A today, lined with huge pine trees. The trees were planted by area pioneer Gus Edwards and would later be torn down as the City of Cocoa Beach expanded the road to make room for its ever-growing population.

In October 1939, Pete and Dale Godke moved to Cocoa Beach with their parents. This photograph, probably taken in the 1940s, shows the brothers with a friend enjoying an early attempt at finding some recreation, specifically by making a shuffleboard court.

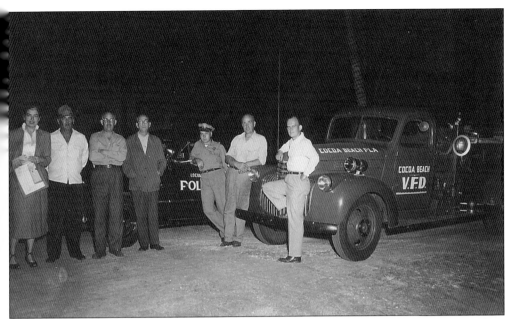

This 1940s photograph shows Cocoa Beach city officials, including city commissioners, police, and volunteer firefighters. The city did not discuss providing trash service until 1942 and was not officially incorporated until June 29, 1957. The population would jump 1,000 percent between 1950 and 1960.

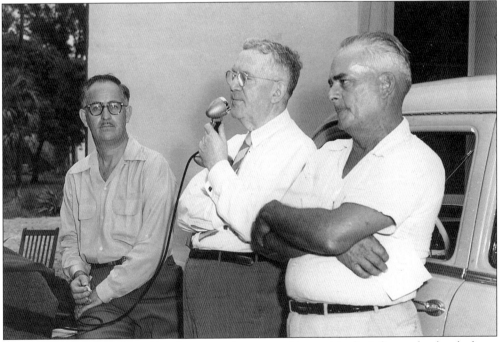

Paul Godke and other Cocoa Beach commissioners test the municipality's first and only telephone in this 1940s photograph. A few years later, a telephone directory manual was printed that included the instructions "How to dial a number" and gave specific instructions for how to place fingers into the rotating telephone dial.

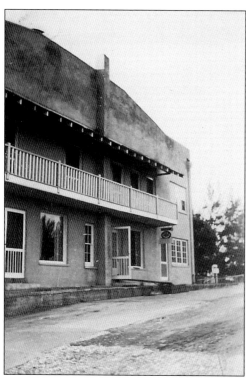

This 1940s photograph shows the Ocean Lodge Hotel, which in 1939 was only one of a few buildings in existence in Cocoa Beach. The other was a Gulf Oil station located about a block away. The lodge was built from materials brought to the area in the 1920s by boat.

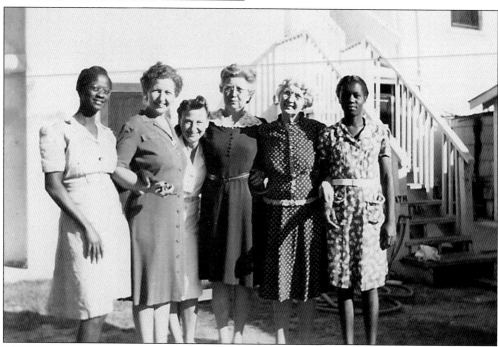

There were not very many residents in Cocoa Beach before the 1950s, and the majority of those who lived in the area had moved to the city to cater to tourists. This 1940s photograph shows Ann Godke and other workers of the Ocean Lodge, which was located at what is now the end of Cocoa Beach Causeway and Highway A1A.

The Cocoa Beach Congregational Church was the first church constructed in Cocoa Beach in 1927. It was built by Gus Edwards and is now located at 350 South Orlando Avenue. According to a report from resident Paul Godke, in 1940 the "first major accomplishment" was starting the Cocoa Beach Community Church, which used the same building. Since then, it has housed Methodists, Presbyterians, and other congregations. The photograph on the right shows Gus Edwards himself standing in front of the church after it was renovated. Next to Edwards is a bell that was cast in Holland and dedicated to his mother in 1955.

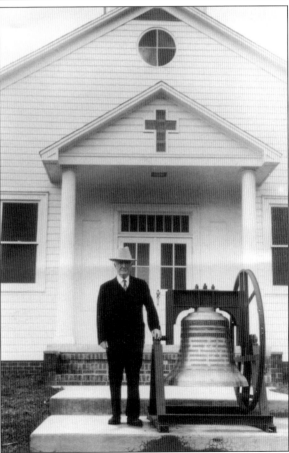

This house, located on the 300 block of South Atlantic Avenue, still exists today and was one of nine houses built in 1929. They were the only houses in Cocoa Beach, and all materials had to be shipped in by boat. The Godke family resided here after moving to the area in 1939.

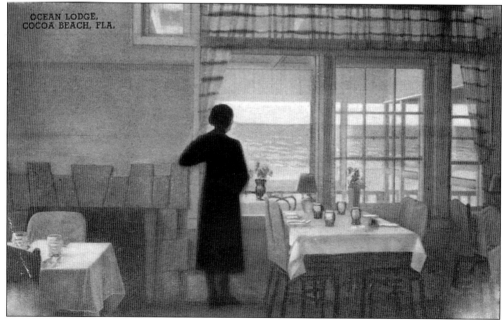

This early Cocoa Beach postcard shows an advertisement for the Ocean Lodge, which was previously known as the Cocoa Beach Casino. The lodge was located right on the beach and was one of the first structures built near the beach.

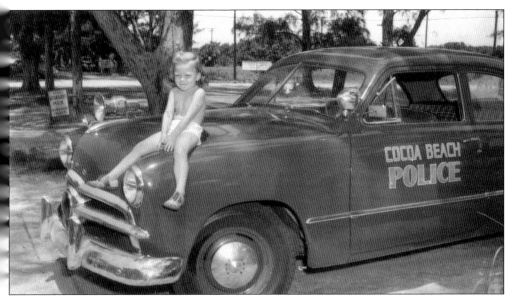

This 1950s photograph shows the Cocoa Beach police car used by town marshal Wayne Headley. The car was owned by Headley and was even painted by him for use in police business. It was later reported by the Headley family that the girl on the car was the marshal's daughter. Headley was the first town marshal and was also part of the first volunteer fire department.

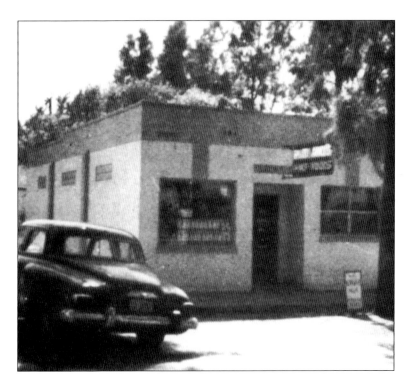

Rudland's Grocery and Meat Market is featured in this 1950s advertisement photograph. In the early years, it was the only grocery store located in Cocoa Beach. Today, after many renovations, a real estate company is located in the building, which still exists across from city hall on Orlando Avenue.

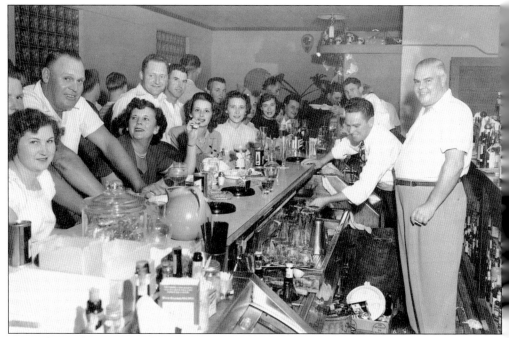

Bernard's Surf Restaurant, located at 2 South Atlantic Avenue (also part of Highway A1A), was one of the most popular hot spots in 1950s Cocoa Beach. The above photograph, taken at the restaurant's bar, shows a sleepy beach town that is coming to life with new residents and visitors. Well-known local Bernard Fischer, the restaurant's owner, would eventually pass on the establishment to his nephew, Rusty Fischer. The photograph below shows some fun partygoers enjoying themselves during a New Year's Eve celebration. Although the exact year is not known, note that the calendar shows December 31.

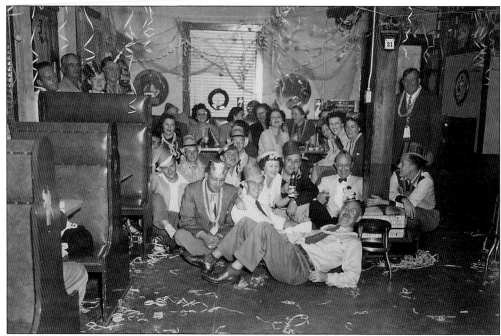

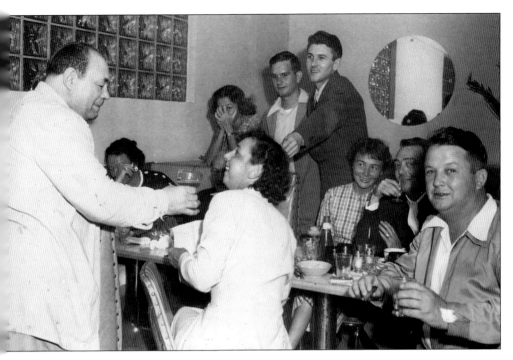

These photographs show more scenes taken inside Bernard's Surf Restaurant during its heyday. Bernard Fischer was often seen interacting with customers; of note is the fact that many more people smoked in those days, and often it was done inside. The photograph below shows a well-groomed and uniformed wait staff at the restaurant, getting ready for the day's customers. The restaurant was opened by Fischer on October 30, 1948, and was sold by his nephew, Rusty, in November 2007. Today it still exists under the new owners and is simply called the Surf Bar and Grill.

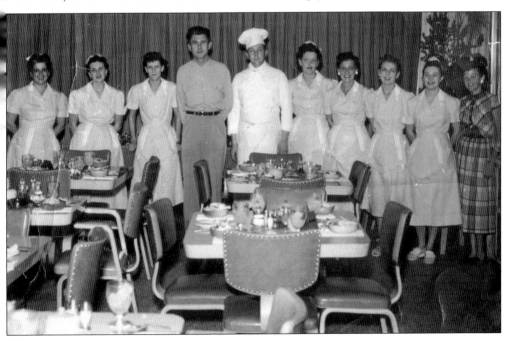

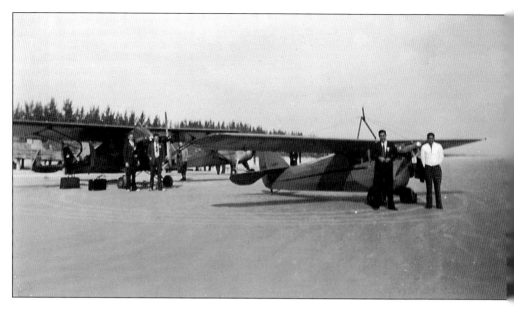

Except for the beautiful sand and ocean waves, the 1940s and 1950s beach was a lot different than it is today. These photographs show Cocoa Beach fly-ins, where pilots could land their planes right on the beach. The above image was taken in the 1940s, while the one below shows over 60 planes that landed around 1952. Due to environmental concerns and beach erosion, cars and airplanes were eventually prohibited from driving and landing on the beach.

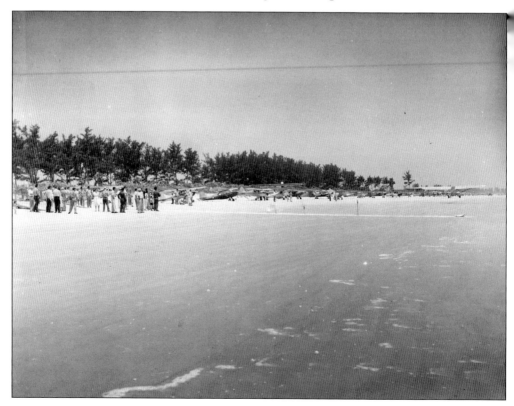

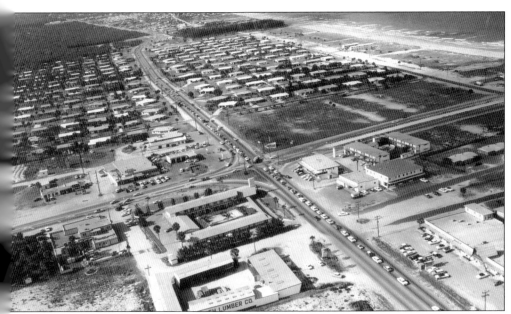

The aerial photograph above from the City of Cocoa Beach archives was probably taken in the late 1950s. It shows the intersection of Highway A1A and Highway 520. At the intersection was the Sea Missile Hotel, a shopping center across the street on the ocean side, and a bowling alley and gas station to the north. All but the shopping center were torn down for new construction. The aerial photograph below was taken looking west from the same intersection at Highway 520, looking toward Merritt Island. The sign for Ramon's restaurant, a popular eatery in its day, is visible near the bottom of the photograph. The communications tower visible in the upper right corner is still there today.

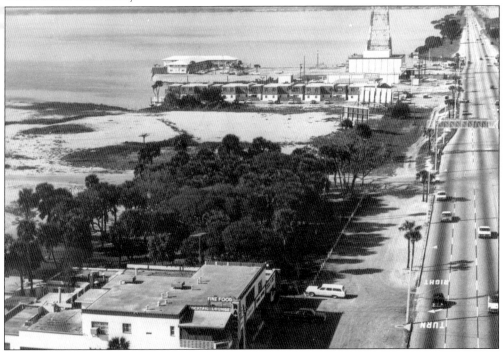

In the 1950s, the population in Cocoa Beach and surrounding areas skyrocketed as a result of the growing space industry. The homes seen in the photograph above were in a real estate advertisement from the 1950s. They were built in the Hurck's Cleggmoor subdivision, located in Cocoa Beach. The homes were typical of the many constructed during the era, when housing demand was so high some families slept in their cars. The buildings in the photograph below are the Bon Air and Beachcomber apartments and were featured in the same brochure, printed by area pioneer Gus Edwards.

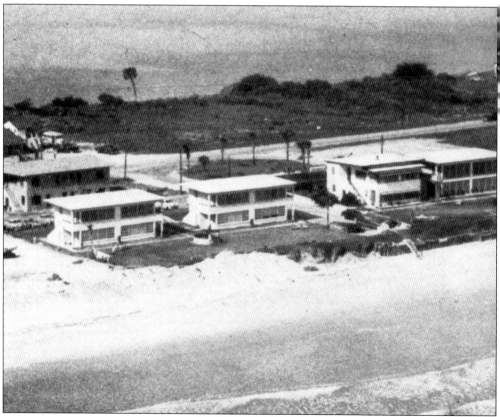

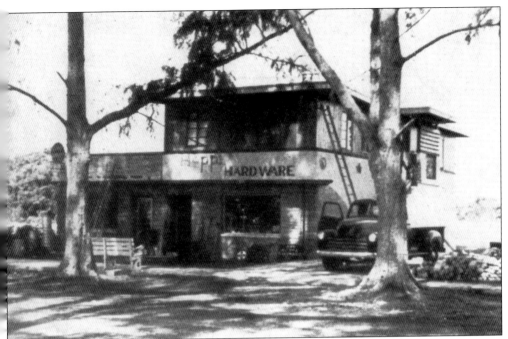

This 1950s photograph shows Hoppi's Hardware store, one of the first establishments of its kind in Cocoa Beach. Although there are a lot of trees and sand surrounding the store in this photograph, today it is surrounded by other buildings. Located in the heart of Cocoa Beach across from city hall at 251 Minutemen Causeway, it still exists today as the Mai Tiki Gallery.

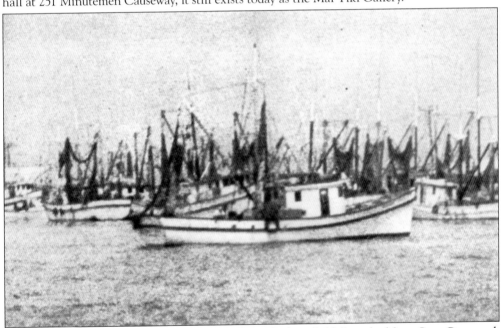

This 1950s photograph shows an entire fishing fleet, which probably launched from Cape Canaveral. Today the area does not have a fleet like this, though charter fishing boats dock at nearby Port Canaveral. The port is the second busiest in the country for recreation cruise lines and is one reason why millions of tourists come to the area each year.

```
                    DR. W. C. WILLIAMS
                EYE, EAR, NOSE AND THROAT CLINIC
                      HILLSVILLE, VIRGINIA

                                      December 2, 1952

Mr. Gus C. Edwards
Cocoa, Fla.

Dear Mr. Edwards,

     Just a note to say, how much I appreciate my new home
at Snug Harbor at Cocoa Beach.
     Before deciding on this place I traveled all over Flo-
rida both east and west and Central part of the state. No
where did I find a place I thought was quiet as nice as Snug
Harbor.
     I find I can take a boat at my front yard and go all the
way to Richmond, Virginia by the inland water way. No, where
have I found nicer fishing grounds.
     I may say I greatly appreciate everything you have done
and, in looking after the construction of my house, also all
the other little favors.
     Am, thanking you again for your kindness I am.

                                      Very truly,

                                      W. C. Williams, M.D.
                                      Hillsville, Virginia
```

Gus Edwards is considered to be the pioneer real estate developer who made Cocoa Beach what it is today. Originally the city attorney for nearby Cocoa, Edwards saw some potential in the undeveloped area just to the east. One of his real estate brochures featured the above letter from Dr. W. C. Williams, who expressed his gratitude for finding a place so quiet and with such great fishing. The brochure even included the photograph below of Dr. Williams's home.

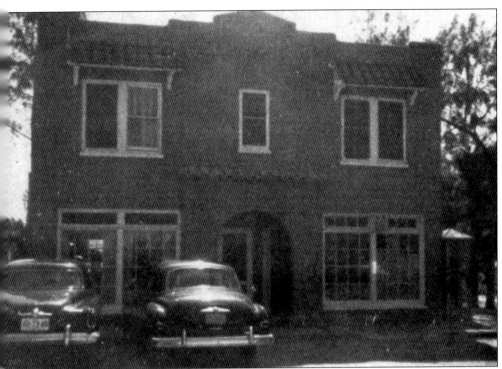

This archive photograph from a Gus Edwards advertisement shows the original Cocoa Beach U.S. Post Office. Oliver Haisten was the first postmaster. At one time, it was the only thing that existed along with the Ocean Lodge Hotel and a gas station. In 1950, it served less than 100 residents. The population would surge to over 10,000 by 1970. The photograph below from the same advertisement shows the original city hall building, located on South Orlando Avenue. A new city hall was constructed in 1961, and after many renovations, it still stands today.

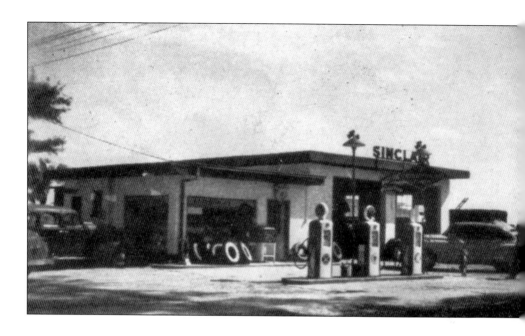

The photograph above shows a Sinclair service station, and the photograph below show Casban's barbershop. Both were part of advertisement brochures put together by area pioneer Gus Edwards in an effort to attract more people to 1950s Cocoa Beach. "Unlimited opportunities for going into almost any kind of business are offered today in fast growing Cocoa Beach and Snug Harbor Estates," Edwards said in the brochures. Little did he know that the community he created would be right in the center of the space race just a few years later, when the population of Cocoa Beach would grow from 50 to 10,000 people almost overnight.

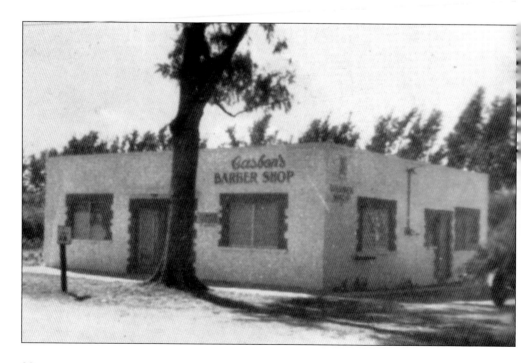

The archive photograph above, probably taken in the early 1950s, shows teens Carylon Powell and Patsy Curry as they enjoy the beach at the White Caps restaurant, located in Cocoa Beach. With 74 miles of coastline making up the Space Coast, there was a lot of beach to explore. The area beaches, though, were not the only attraction for kids who needed to cool off. Finding some fun on the hundreds of miles of rivers and waterways around Cocoa Beach and its surrounding communities was a typical pastime for teens in the 1950s, as seen below in the city archive photograph from that era.

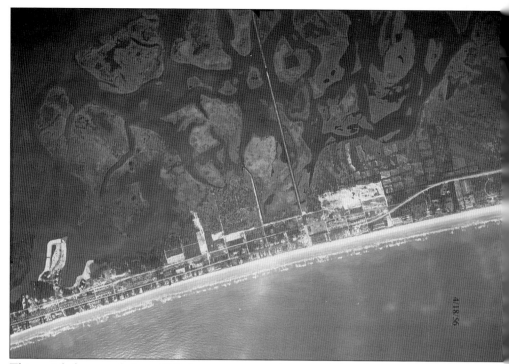

This aerial photograph from 1956 does not seem to show much, but that was only because there was not a lot of development yet in Cocoa Beach. Until the late 1940s, there were only about 50 or so official residents of the beach town. As the late 1950s approached, the space race would kick into high gear and change the landscape of Cocoa Beach forever.

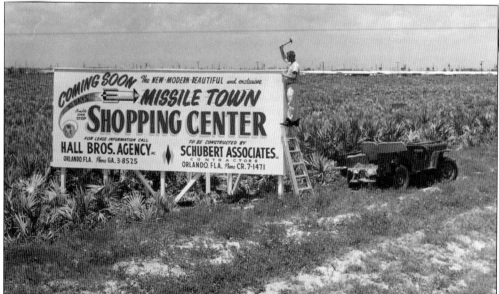

This undated photograph of a shopping center advertisement shows how the space race influenced everything along the coast in the communities surrounding what would become Kennedy Space Center. Retail stores, hotels, motels, and even school names reflected the dramatic change brought to the area over a period of just a few years.

The girl in this undated 1950s archive photograph is getting her picture taken with a radio, which was the prize for a Cocoa Beach fly-in contest. Aircraft landing on the beaches was not uncommon until after the 1950s. Cocoa Beach is just part of the 74-mile coastline that makes up the Space Coast. The area beaches were always an attraction for residents and visitors, but that attraction would really take off after a converted German V-2 rocket was launched from Cape Canaveral in 1950.

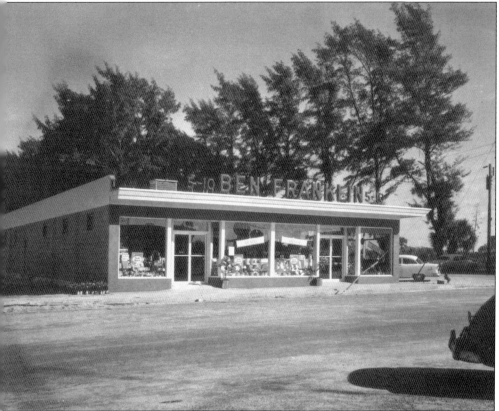

The 5-and-10 Ben Franklin store in this 1950s archive photograph was built at 2 North Atlantic Avenue right in the heart of Cocoa Beach. Some retail owners at the time were worried about a franchise business coming into the town, but eventually the store was replaced by a restaurant.

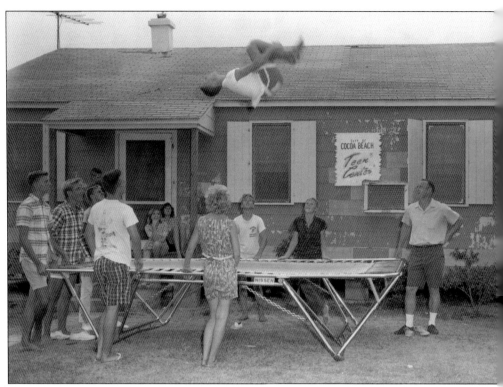

With the space race of the 1950s came tremendous growth to Cocoa Beach and its surrounding areas. As workers moved to the area to work for the space program, they brought their families with them. This photograph shows a teen center built by the City of Cocoa Beach.

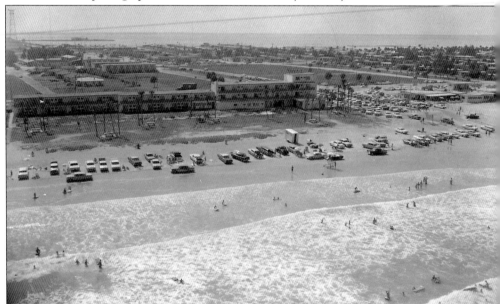

This early-1960s photograph shows just how popular Cocoa Beach was as a fun tourist destination. More hotels, like the Vanguard, were being built to accommodate the new visitors, and people would drive their cars right to where they wanted to bathe in the sun.

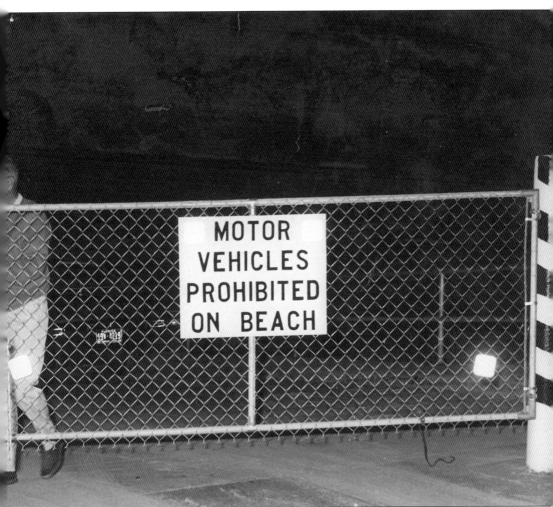

For decades, people were allowed to drive cars and even fly planes right onto the beach, but in 1969 that part of Cocoa Beach history came to a close. Cars would no longer be allowed on the beach, as people started to get concerned with keeping the sand beautiful for future generations.

The girls in these 1950s and 1960s photographs are showing off on Cocoa Beach, which, along with the rest of the area's coastline, is today the closest beach to Orlando's Disney World theme park. In 1950, long before the park was created, the population in Brevard County was 23,600. By 1960, the onset of the space race had surged the population to 111,435, and in 1969, when men landed on the moon, it was 250,000. By 1971, when Disney World was built, though, the population had lowered to about 230,000. Congress was trimming the nation's space budget, and along with it, the workforce at Kennedy Space Center was cut by about 40 percent. County planners would begin to look for ways to attract new people with industry and tourism.

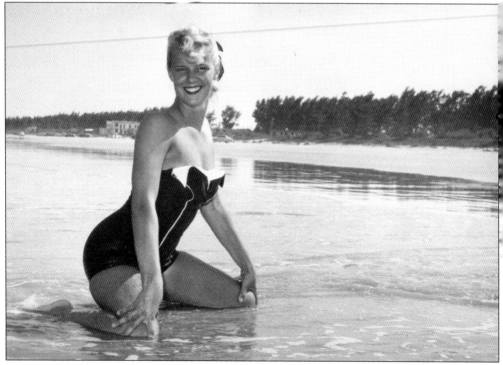

This early-1960s photograph shows an early view of the intersection of Highway A1A and Highway 520. The Sea Missile Hotel, seen in the background, was built in the 1950s and is now a CVS Pharmacy store. Just across the street now is the famous Ron Jon's Surf Shop, where once stood a hotel.

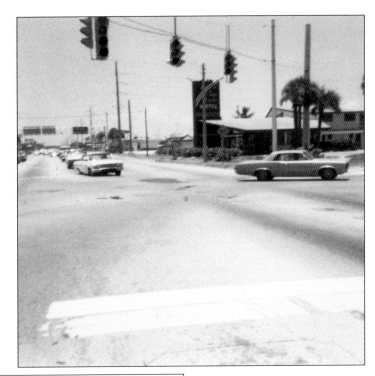

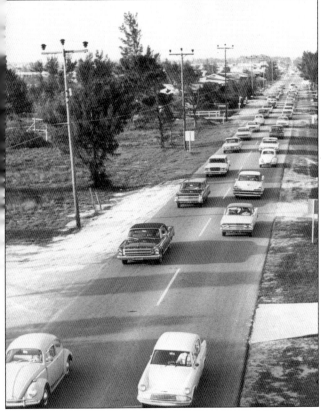

This 1960s photograph shows Orlando Avenue, which is part of Highway A1A, as it looked during the space heyday. Cars jammed the road as workers went to and from their jobs working on the nation's space program. Today some of the trees still exist in residential areas, and the road is just as packed during tourist season.

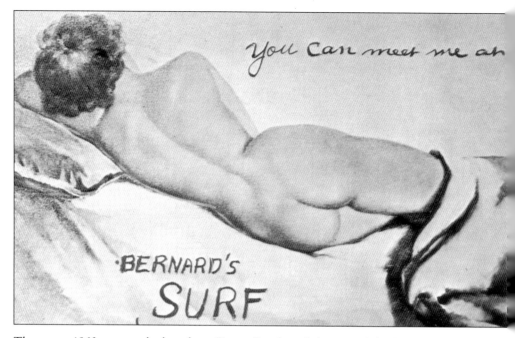

These two 1960s postcards show how Cocoa Beach and the rest of the Space Coast began to advertise themselves as a fun place for tourists to visit. Above is a postcard for the popular Bernard's Surf Restaurant, and the image below shows several attractions like entertainment inside the Starlite Motel, families at the beach, a NASA rocket launch, and people fishing. The increasing activity in the area was no surprise, as its population increased from around 23,000 in 1950 to 250,000 in 1969. Ironically, attracting tourists during the era of the moon landing probably was not an issue, as thousands of cars would jam the roads watching each and every rocket launch.

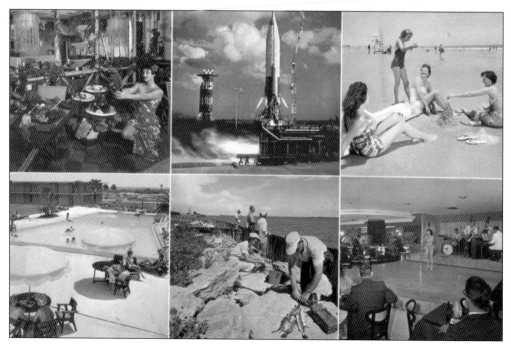

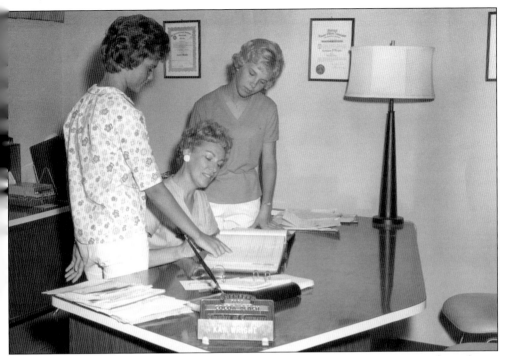

This photograph shows Cocoa Beach resident Kay Wright and two City of Cocoa Beach employees hard at work on city business. Wright was the city clerk in the 1960s and city manager in the 1970s. She witnessed tremendous growth that necessitated the building of a new city hall, fire station, and library.

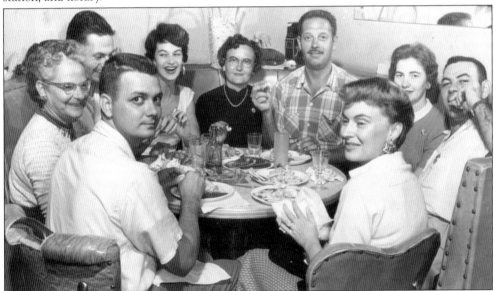

Mayor Robert P. Murkshe is seen smoking a cigarette in this 1960s photograph (seated sixth from the right) in the middle of a table of friends. Murkshe is a well-known past mayor of Cocoa Beach, and today there is even a park named after him. Others identified in the photograph are, from left to right, Roger Beatty, Micky McMahon, Charles Scott, Jane Scott, Betty Murkshe, and John Nicola.

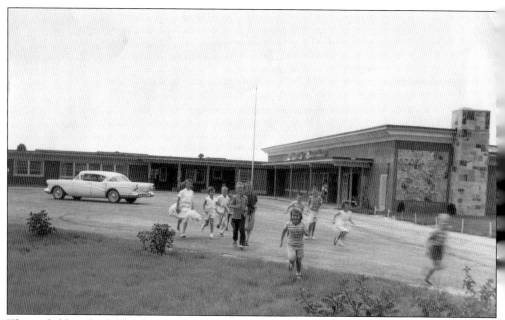

These children look like they are having a great time in this 1960s archive photograph taken at Cocoa Beach Elementary School. The school was part of the infrastructure that city and county officials had to create when the space race hit Brevard County in the late 1950s. Municipal services, hospitals, and police and fire departments would all have to change with the population explosion.

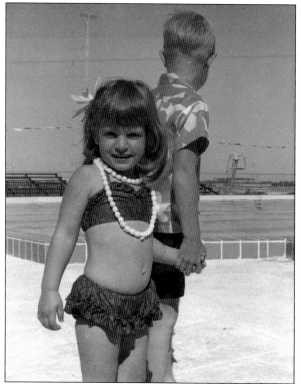

The kids in this 1960s photograph are getting ready to enjoy the swimming pool at Cocoa Beach Country Club, located at the end of Minutemen Causeway at 500 Tom Warriner Boulevard. The country club is owned by the City of Cocoa Beach and was built on a peninsula surrounded by the Banana River Lagoon.

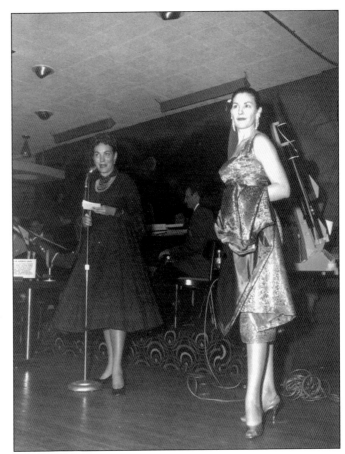

The 1960s photograph on the right shows a fashion show in the Satellite Motel, one of many hotels and motels constructed during the space boom that today no longer exist. The Vanguard Motel, Sea Missile Hotel, Samoa, and Holiday Inn were also popular during that time. Of them all, only the Holiday Inn, which was a popular spot for Mercury astronauts, still exists today. Its appearance is much more modern since an expansion and renovation. The below photograph shows a 1960s postcard advertisement for the beachside Vanguard Motel, which advertised having efficiency apartments, a swimming pool, cocktail lounge, and dining room.

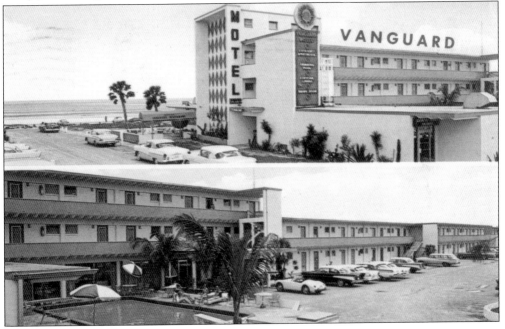

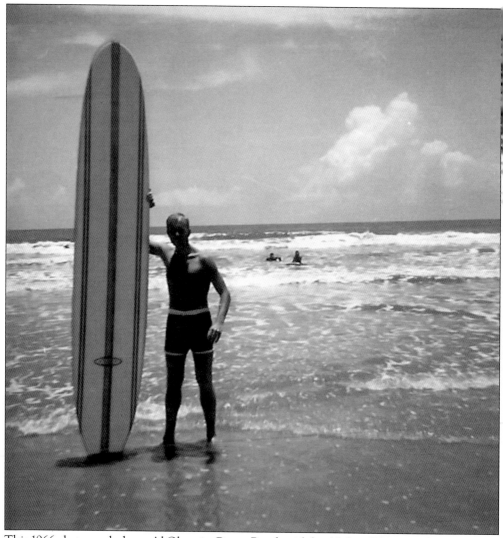

This 1966 photograph shows Al Olson in Cocoa Beach with his 10-foot O'Hare surfboard in front of what was the Diplomat Apartments. Olson was like a lot of people who enjoyed the waves as a pastime while working at the space center. He was a Chrysler Corporation employee who worked on the Apollo program from 1965 to 1975 and eventually worked on the Space Shuttle program until his retirement in 1998.

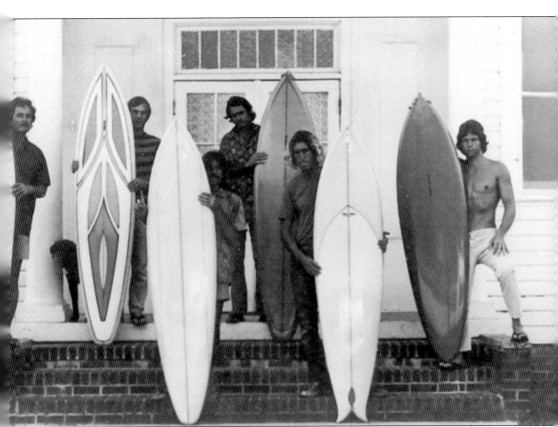

This photograph, taken in the 1960s, shows Patrick O'Hare and his surfing crew as they gather in front of what was the Cocoa Beach Community Church before hitting the waves in Cocoa Beach. By that time, surfboards had become a common site, and the area became known for its surfing culture.

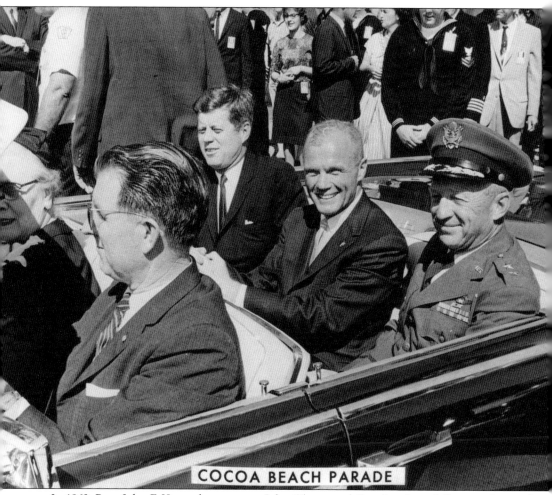

COCOA BEACH PARADE

In 1962, Pres. John F. Kennedy, astronaut John Glenn, and Gen. Leighton I. Davis rode together during a parade in Cocoa Beach, as seen in this photograph. Glenn had just completed his Mercury Friendship 7 spaceflight and had become the first American to orbit the Earth. After Glenn's flight, he was a national hero, in no small part because everyone everywhere in the world was watching the events on television. Those historic space flights drew thousands of people to Cocoa Beach and its surrounding communities, eventually having so much influence that the area would become known as Florida's Space Coast.

Two
Cocoa

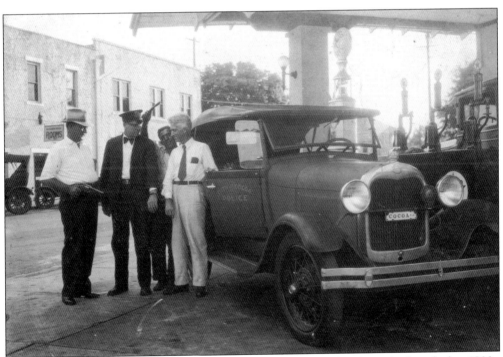

Cocoa is one of the oldest areas in Florida's Space Coast, with families dating back to the late 1800s. This photograph, probably taken in the 1920s, shows city officials and a Cocoa police car at a gas station on the corner of Brevard Avenue and Oleander Street. In the background is the Oleander House, which offered rooms for rent at 15 Oleander Street and today is a retail establishment.

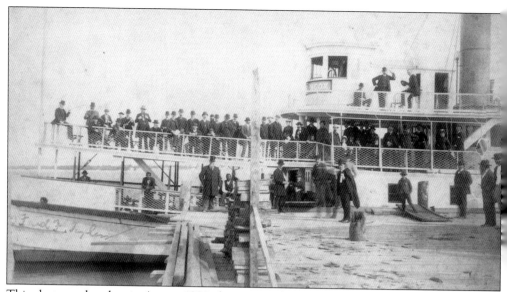

This photograph, taken in August 1890, shows a riverboat at the Cocoa Dock. By around 1885, a steamer line was in use between Sanford, Florida, and what was the farthest landing to the south on the St. John's River, about 3 miles south of Cocoa. Eventually riverboats were a common sight on the rivers as more people came to the area.

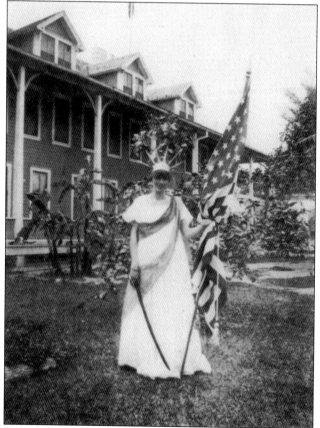

This photograph postcard was sent to Mrs. F. W. Schultz on May 12, 1917. "This is a picture of Maude Hindle who was Columbia in the May Day parade. I forgot to tell you that the Red Cross took in 88.70 at the Silver Tea Thursday," the card says.

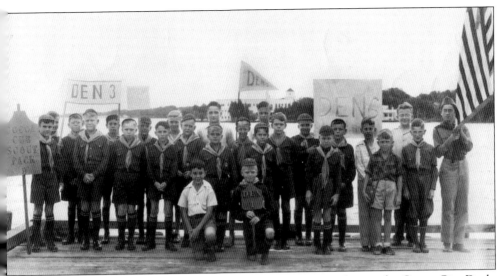

This undated photograph of Cocoa Cub Scout Pack No. 9 was taken at the Cocoa City Dock. In the photograph are (first row) Frank Sullivan and Peter Thomas; (second row) David Daniel, Strube Jackson, Mike Thomas, Roby Buckalew, Edgar Buck, Charles Dona, Bill Jackson, Harrison Boley, Jay Gould, Charles Hill, Bruce Watson, Robert Buck, James Patrick, Jim Sawyer, Charlie Provost, William Weathers, Robert Thompson, C. C. Sellers, and Rawson Buck.

The little boy dressed as a fisherman and the little girl in tropical costume with a ukulele in this undated photograph were probably part of an Armistice Day parade in Cocoa. The day was primarily set aside to honor veterans of World War I and was held on November 11, the day the war ended in 1918.

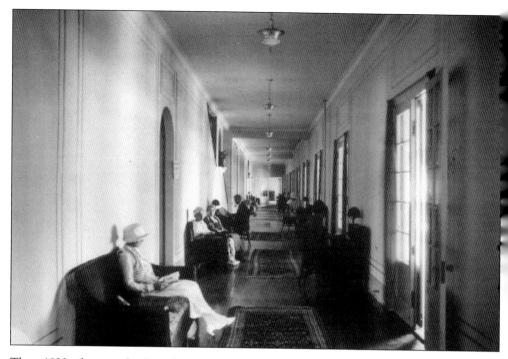

These 1920s photographs show the inside of the famous Brevard Hotel, which opened in 1923 and was torn down in the 1990s. It originally had 57 guest rooms, then was expanded and reopened in 1934 after being closed in the late 1920s. Many of the windows, fixtures, and furnishings, however, can still be found at Murdock's, located at 600 Brevard Avenue. The hotel was well known as an example of the glitz and glamour of the era.

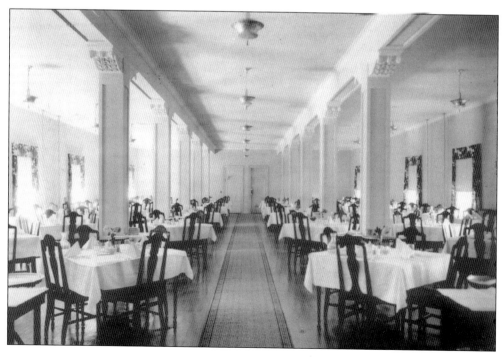

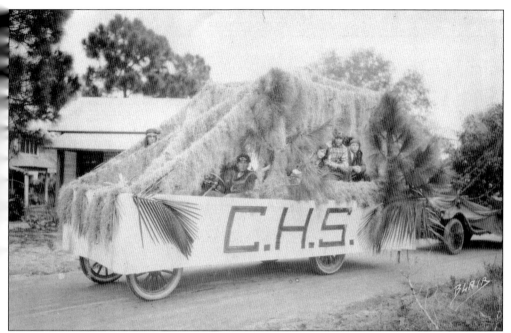

This 1924 photograph shows a Cocoa High School parade float, probably made for the area's Orange Jubilee celebration. Some of the most well-known families from the area got their start, as far back as the 1800s, by growing oranges. Today oranges are still grown in Brevard County.

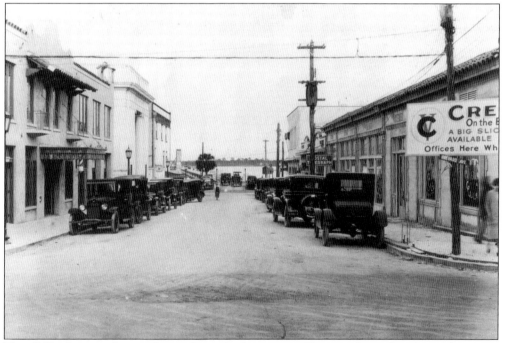

This 1920s photograph was taken in Cocoa looking east on Harrison Street from Brevard Avenue. Note the number of cars and development in the area as compared to Cocoa Beach, which was not even incorporated until 1925. The first families came to Cocoa around the year 1860, and the first commercial building was erected around 1881.

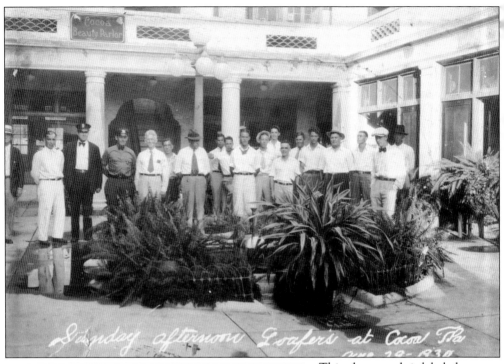

This photograph is labeled "Sunday afternoon Loafer's at Cocoa Fla. June 29, 1930." It was taken in the Belair Courtyard, which is located at 264 Brevard Avenue and is still a popular retail location today. The building dates back to at least 1920. Included in the photograph are Louie the Greek, Pop Bryant, Trigger Griggs, Red Burnett, and Jerry Sellers.

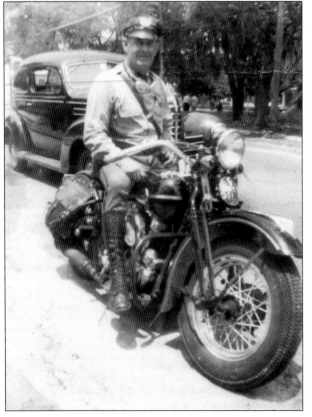

This undated photograph, probably taken in the 1930s, shows Earl "Trigger" Griggs, who was the first motorcycle patrolman in Brevard County. Griggs was a deputy with the sheriff's department and patrolled the entire county.

The photograph on the right was taken on Oleander Street, and the girl posing on the bumper of the Black Hat Dry Cleaners truck is Rachael Duke Bobowicz. The license plate header reads "1937 Florida." The photograph below was also taken on Oleander Street but just a little farther to the west, in front of the cleaners itself. The girl in the photograph is Marion Patterson, who later got married and took the last name Jackson. The cleaner's window advertises that felt hats can be cleaned there. The business went through different owners over the years. Today the cleaners no longer exists but is now a gift shop named the Village Gingerbread House.

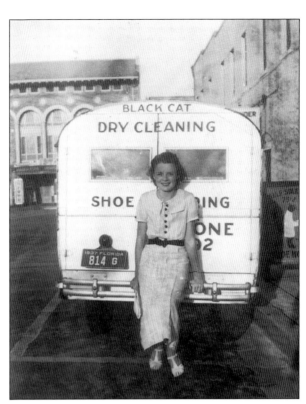

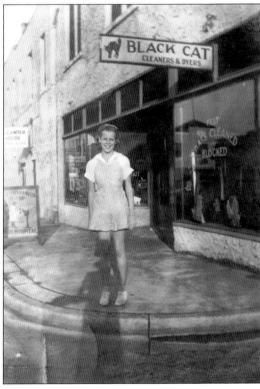

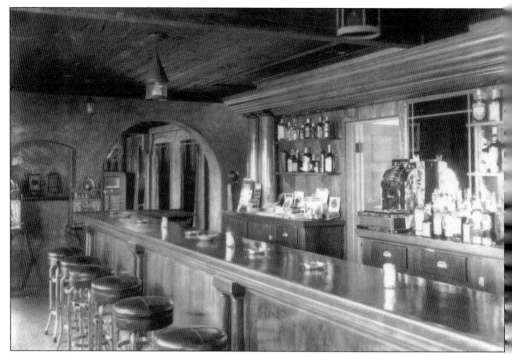

This photograph of the inside of Jack's Tavern, an establishment owned by Jack Allen, was probably taken in the 1930s. The bar, located on U.S. Highway 1, was opened after the end of Prohibition, and was even featured on television as supposedly being haunted. After going through many name changes over the years, today it is known as Ashley's.

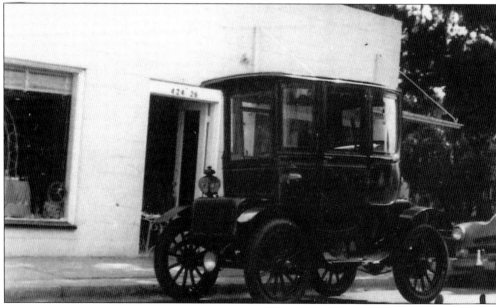

This photograph, probably taken in the early 1940s, shows the address of 424 and 426 Brevard Avenue, which at one time was a florist shop. The address itself no longer exists, and today a bank is located where the business once stood. Of note in the photograph is one of the first types of electric cars available anywhere.

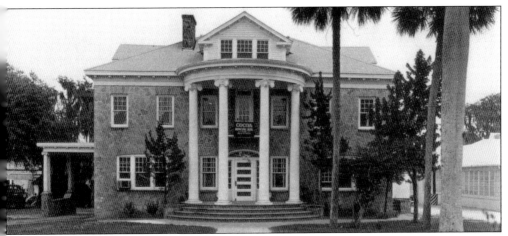

Seen in this 1950s photograph is the Porcher House, which was built by Edward Postell Porcher in 1916. Porcher was a pioneer in the citrus industry and even invented a machine to wash his crops. Over the years, the house was used as the City of Cocoa Municipal Building. Today it is available to the public for special events.

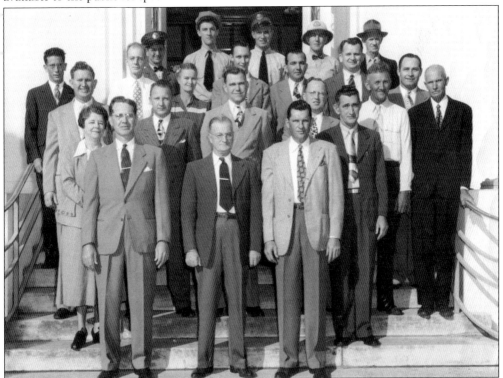

This 1950s photograph shows workers in front of the U.S. Post Office at 435 Brevard Avenue in Cocoa, which opened for business on April 21, 1940. It was built in 1939 at a cost of $70,000. Pictured from left to right and front to back are Frank Johnston, A. E. Booth, Ivan Townson, Eva Powell Ford, Leon Garvin, Delbert Krepps, Bill Speith, Carroll Booth, Charlie Johnston, A. V. Yancy, Don Stradley, unidentified, George Leighty, Vic Edwards, Charles LaRoche, Speedy Harrell, Hoke Holmes, Jim Caldwell, and Ashley Buck, Carl P. Geiger, Felton Butler, Barr O'Hara, and Harvey A. White.

The 1948 photograph on the left shows student Bess Ringo and teacher C. E. Hoyt enjoying a "sand sailer" that was built in Cocoa High School. The sailer was probably built as part of a class project and tested on Cocoa Beach. A banquet probably held for the Cocoa High School class of 1952 is seen in the photograph below. The event was sponsored by a Baptist church group. The school was dedicated in 1917, and on September 25, 1925, it opened a new four-story building. Today it has a campus with about 1,200 students.

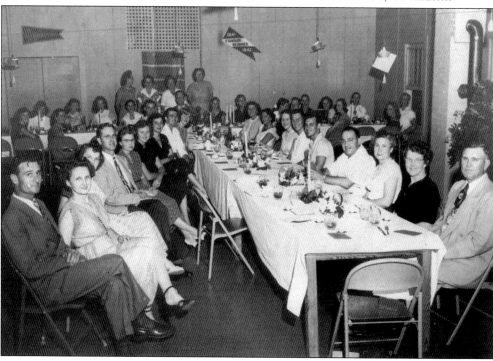

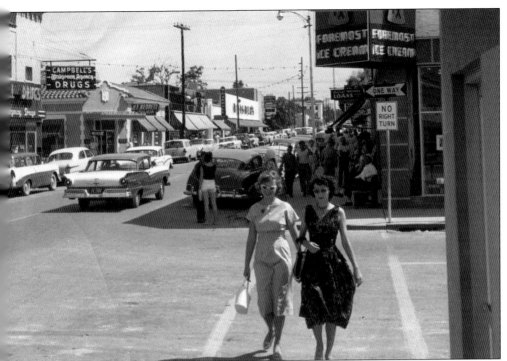

It was the 1950s, and Brevard Avenue in Cocoa was a thriving center for shoppers, as seen in the photograph above. Campbell's Drugstore on the left is now a gift and jewelry shop. Today the area is known as Cocoa Village and still attracts shoppers and tourists every day. The photograph below shows the same Brevard Avenue just a few years earlier, except that one can see the Historic Cocoa Village Playhouse, which was established as the Aladdin Theatre in 1924 and was later known as the State Theater. Note the sign advertising that the theater is air-conditioned on the front of the building.

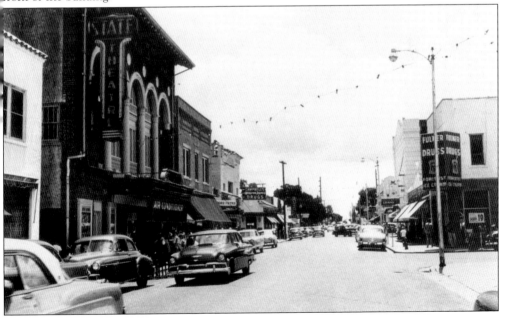

In the 1947 photograph on the left, Norma Jean Leighty Baird and Beverly Cooper LaRoche ride in a car for the Greater Jaycees of Cocoa in the Orange Jubilee Parade. It was most likely taken on Brevard Avenue. The photograph below shows another parade, which might have been held to celebrate Armistice Day. A navy band is marching down Brevard Avenue, and in view are Myrtle's Restaurant, a bowling alley, Hob Nob dining room restaurant, and Kershaw Insurance Agency. A hotel is barely visible in the far background of the photograph.

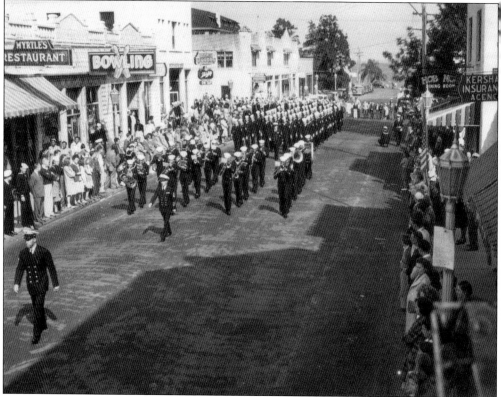

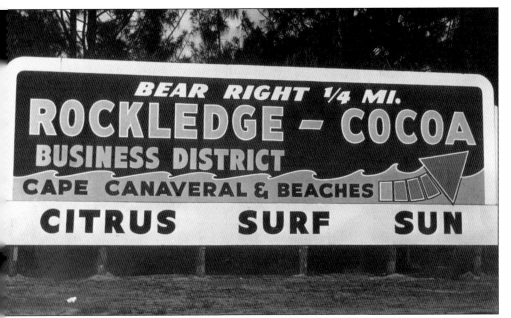

The sign in this 1950s photograph directs people to the Cocoa area and lets them know the beach is not far away. Note the advertisement for citrus, which was a major product in the area going back to the late 1800s. The surf and sun were also hot commodities.

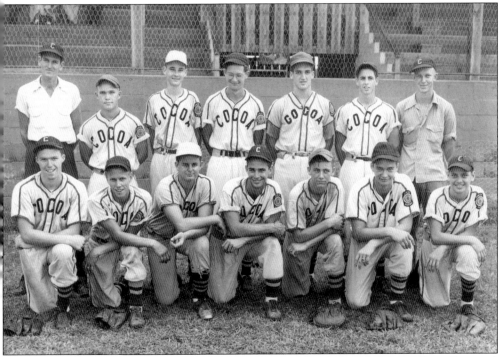

This photograph shows the 1951 Junior American Legion baseball team. Pictured are (first row) Maurice Campbell, Dale Bryant, Dean Mink, Joey Prine, John Barnes, Bob Pereira, and Bob Anderson; (second row) Mitchell Tidwell (coach), Turk Adkins, Bob Brewster, Dave Pereira, Jay Gould, Arthur Mackey, and Russell Roesch (manager).

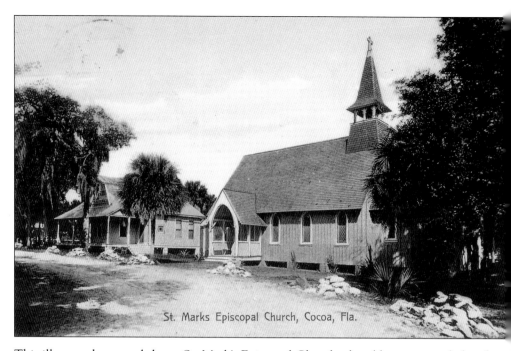

This illustrated postcard shows St. Mark's Episcopal Church, the oldest organized church in Cocoa. Work started on the church in 1886, and a Christmas tree was erected that year on the site even though the church was not finished. The church still exists today and in fact has a school affiliated with it called St. Mark's Episcopal Academy. The photograph below shows a 1962 student classroom at the school. Pictured with teacher Sybil Baezler are (first row) Carl Arnold, Carol Berline, Bill Howard, and Anita Smith; (second row) Mary Eschbach, Charles Smith, Trey Blyth, and Law Schenk; (third row) Teddy Reinholtz, Stephanie Arnold, and Bobby Ackroyd.

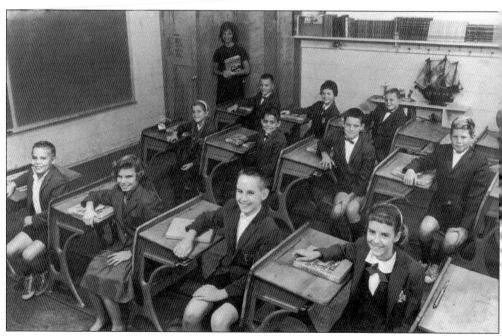

Three
Cape Canaveral

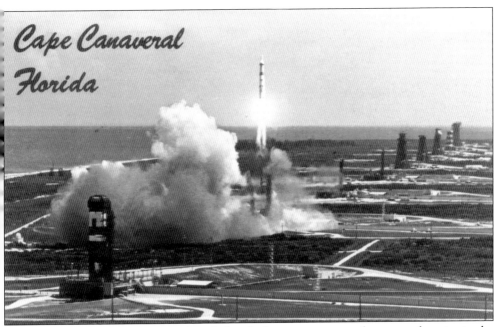

Cape Canaveral is probably more identified with the space program than any other city in the Space Coast. This postcard advertising Cape Canaveral shows a rocket launch from what became known as "Rocket Row," which was located north of Port Canaveral and today is part of Cape Canaveral Air Force Station. The row was a series of launch pads built for NASA's first missions into space.

Not much is known about these 1920s photographs from Cape Canaveral; however, they do show something about the area. Although there were not many residents in Cape Canaveral—in fact, it was not incorporated until June 1962, by just 200 voters—these photographs show that there were some businesses open for residents and tourists. In 1925, the Canaveral Harbor Improvement Company, which consisted of businessmen from West Palm Beach, Miami, and Connecticut, put up a mile-long tract of land near Canaveral Harbor. They called their land "the loveliest spot in Florida."

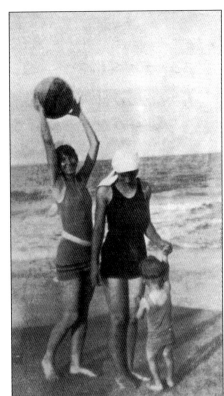

These undated photographs, probably from the 1920s, were taken in the Cape Canaveral area. The photograph on the right shows Florence Honeywell, Gertrude Honeywell Swanson, and her son Raymond Packard Swanson enjoying a fun day at the beach. The photograph below shows Mary Agnes Key and Florence Honeywell.

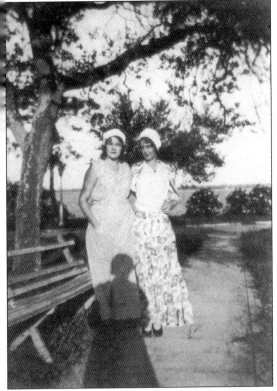

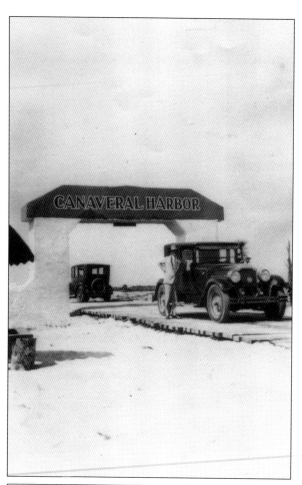

The 1920s photograph on the left shows a sign welcoming people to Canaveral Harbor, which would later become known as Port Canaveral, and also included a boardwalk. At that time, there were very few people in the Cape Canaveral area and even fewer buildings. The photograph below, also from the 1920s, shows another view of the boardwalk at Canaveral Harbor and people enjoying the sun and sand, even if they were somewhat overdressed by today's standards.

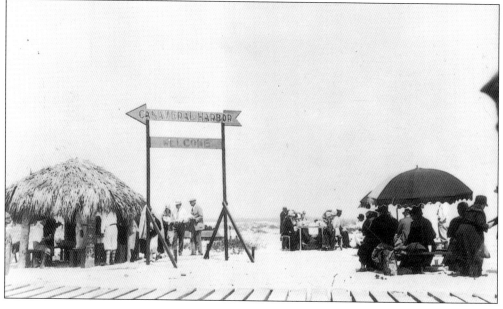

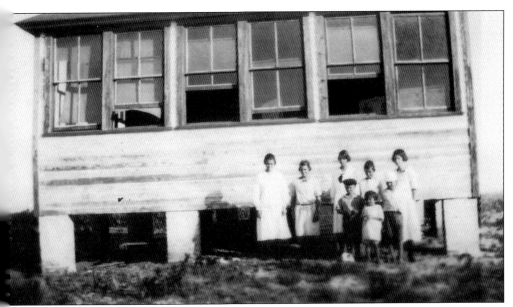

This is probably the earliest photograph of a schoolhouse in Cape Canaveral, most likely taken in the 1920s. Pictured are (first row) Louis Merchant, Irma Merchant, and Elliot Burns; (second row) Meredith Burns, Catherine Burns, Florence Honeywell, Clinton Honeywell, and ? Tucker.

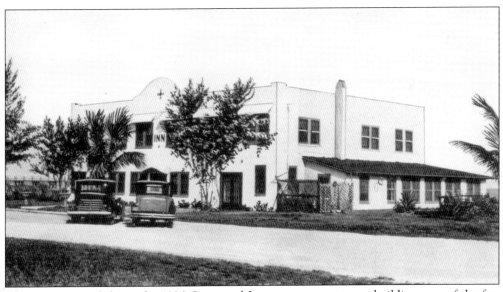

This rare postcard shows the 1926 Canaveral Inn, a two-story stucco building, one of the few places to stay near the beach in the earliest days of Florida's Space Coast. All supplies and mail during the time the inn was in business were delivered by boat. One convenience reportedly available at the establishment was electricity, provided by the use of a generator.

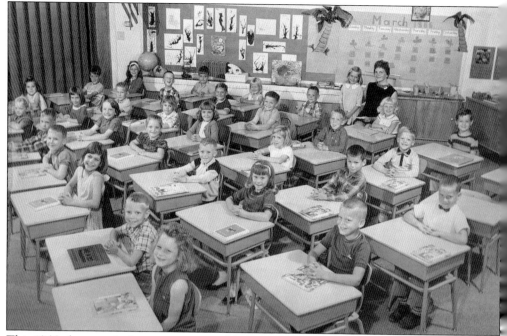

This 1966 photograph shows some excited students at Cape View Elementary School, located at 8440 Rosalind Avenue, getting their yearly picture taken. The school was just a small part of the infrastructure built in the 1960s, when families moved to Florida's Space Coast in huge numbers.

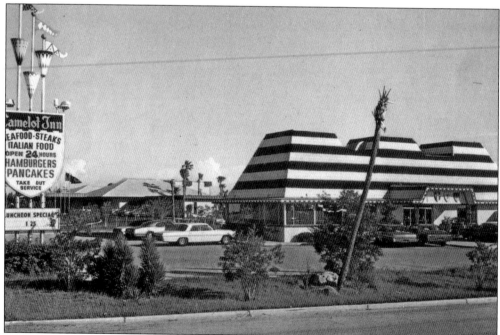

This 1960s photograph postcard shows the Camelot Inn, one of many hotels and motels built during the 1960s space race boom. Once located at the intersection of West Central Avenue and Astronaut Boulevard, the hotel no longer exists. Today an amusement park sits in the same spot.

Four

MELBOURNE

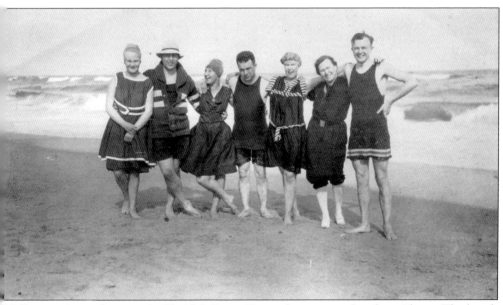

Melbourne is another area in Florida's Space Coast that attracted early residents. The beach sunbathers in this undated photograph probably lived in Eau Gallie (part of Melbourne today) and traveled to the beach to have some fun in the Atlantic Ocean. Even if a person could afford a car, getting to the beach in those days was a much bigger undertaking than it is today.

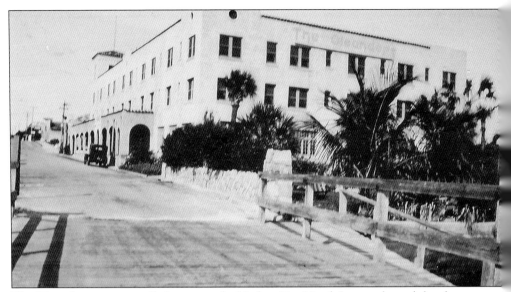

The Oleanders was originally known as the Harbor City Hotel. It once showed the elegance and style of an earlier era. It was located near the Eau Gallie Bridge but suffered a loss of business during the year 1926. During the 1940s, the hotel went through a revival but eventually was torn down in 1990. Eau Gallie is now part of Melbourne.

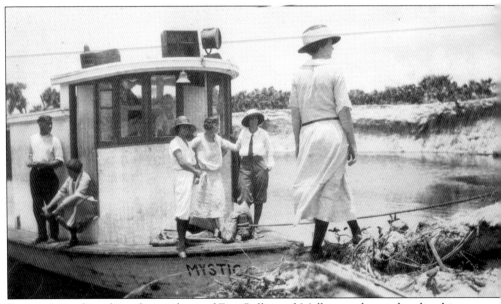

Even in its earliest days, the residents of Eau Gallie and Melbourne knew they lived in an area where they could enjoy the sun and water. The photograph above is part of the Rossetter family historic collection and shows a boat named *Mystic*, which was used on the Eau Gallie River. In addition to recreation, boats like this one provided supplies and even the mail in the early days of the area.

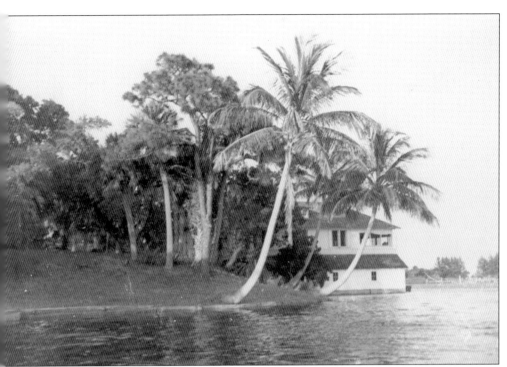

The 1950s photograph above shows a boathouse owned by the Rossetter family on the Eau Gallie River. The photograph on the right shows the main residence for the Rossetter family. James Rossetter purchased this home in 1903 and proceeded to enlarge the home from its original footage, which was built by slaves. Rossetter originally operated a wholesale fish house and later operated a Standard Oil Franchise. Rossetter's daughter, Carrie, was the area's Standard Oil agent for decades afterward.

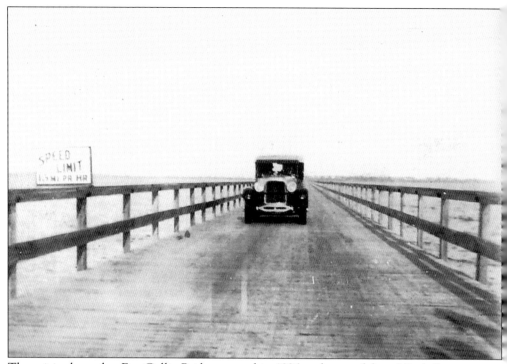

The original wooden Eau Gallie Bridge opened in 1926 and crossed from Ninth Street to just south of the tip of Merritt Island. The bridge had a hand-operated draw, cost 25¢ per car and an extra 10¢ per passenger to traverse, and was always in danger of catching fire thanks to thrown cigarettes.

This Standard Oil Company gas station, located on Eau Gallie Boulevard, could have been owned by James Rossetter, who owned the Standard Oil franchise for the area. One of the little signs hanging below the company name advertises "Ladies Rest Room."

In 1921, the first high school class in Eau Gallie graduated with just 13 students. The postcard above shows one of three Eau Gallie school buildings, this one built in 1926. It is one of the oldest existing structures in Melbourne. The other two buildings exist adjacent to this one, and today the oldest building is still operated as the Henegar Center for the Arts. In 1949, the Eau Gallie High School combined with Melbourne High School. The photograph on the right shows a 1925 Eau Gallie High School sports team.

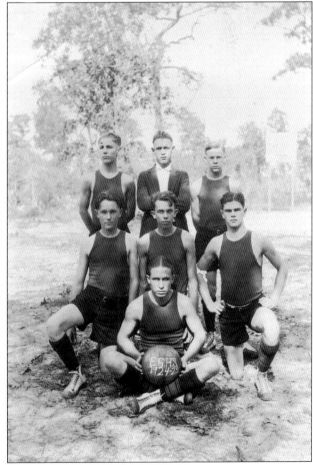

The photograph above shows Highland Avenue, looking north from Eau Gallie Boulevard. In view to the right is the Mediterranean Revival city hall, which replaced an older wooden building in 1925. The retail shop on the left, advertising Coca-Cola, today is the Eau Gallie Florist. The city hall building, pictured on the left as seen from the front, housed the fire department on the left and the police department on the right. Today the city hall building has been renovated, and the popular Brevard Art Museum is located there.

Five
MERRITT ISLAND

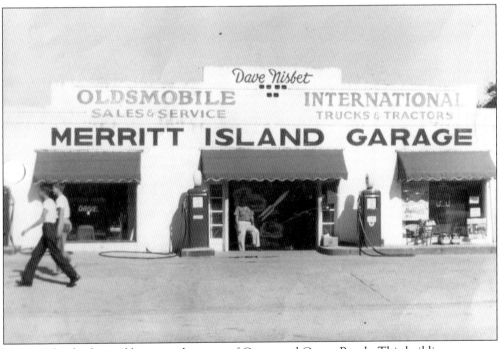

Merritt Island is located between the cities of Cocoa and Cocoa Beach. This building was once owned by brothers Bill and Ira Headley, who sold their business to Dave Nisbet in the 1940s. Of note are the old gas pumps, right in front of the building. It was located at the corner of Highway 520 and Tropical Trail in Merritt Island. Today a 7-Eleven convenience store sits in that location.

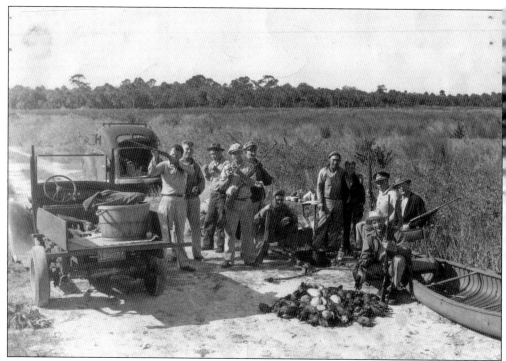

This photograph shows hunters on Merritt Island, which is still an unincorporated community located between the Indian and Banana Rivers. Until the increase in population from the space race, the primary industries on the island were based on cattle, pineapple, sugar cane, and citrus. Included in the picture are A. C. Britt, Mark Collins, Plezzie Coleman, Walter Coleman, Battling Maliki, C. W. "Bo" Coleman, and Gen. Stoney Coleman.

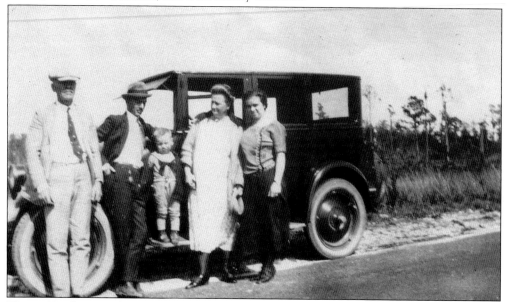

This 1920s photograph was taken at the Olson homestead in Orsino, which was north of what was known as Merritt City. From left to right are Andrew Olson, his son Joseph Olson, grandson Arthur, Andrew's wife, Emma, and daughter-in-law Freida.

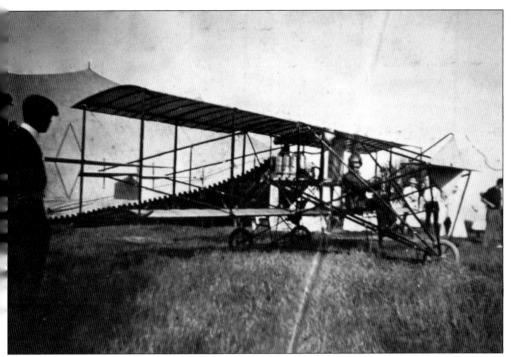

This photograph shows what was undoubtedly one of the earliest aircraft landings on Merritt Island. It is unknown where it landed, but today an airport exists south of Highway 520 on South Courtenay Parkway. The Merritt Island Airport was constructed in the 1940s.

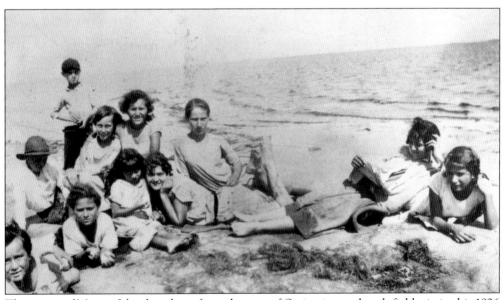

This group of Merritt Island students from the area of Orsino is on a beach field trip in this 1926 photograph. They did not wear bikinis in those days, and getting to the beach was a lot harder than it is today. Included in the photograph are Roger Crabil, Annie Furrari, and members of the Garafolo family.

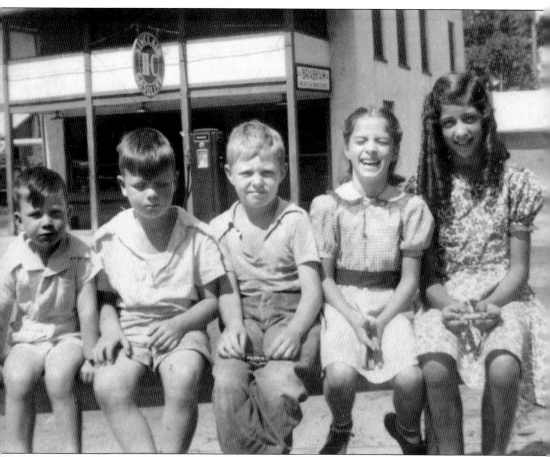

These kids are enjoying themselves in front of the J. A. Brabham Grocery Store and Sinclair gasoline station, located north of Highway 520 on Tropical Trail in Merritt Island. Included in the 1930s photograph are Ray Dewey, Dora Frances, and Halcie Dewey Massey.

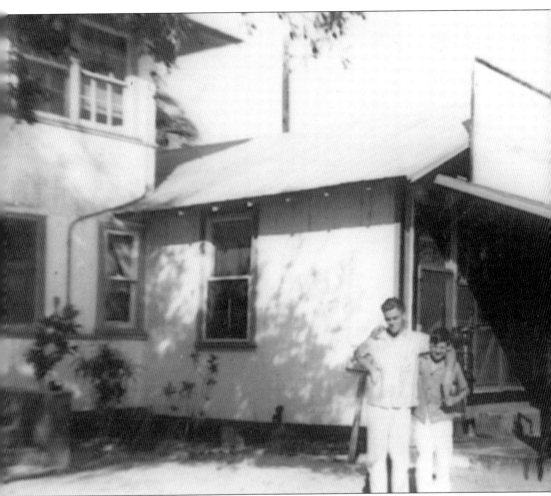

This 1930s photograph shows Lindner's Store, one of the few retail establishments at that time in Merritt Island. It was located in Lotus, which was an area about 8 miles south of Merritt City on the Banana River. The boy on the right is Tommy Johns Waddell. A house was attached to the left, and the establishment's supplies were useful when no real grocery stores even existed in the area.

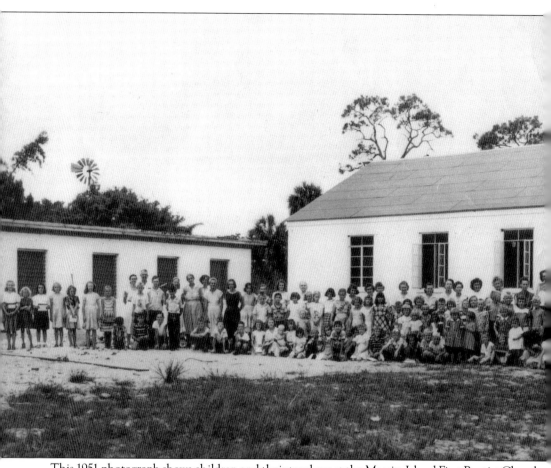

This 1951 photograph shows children and their teachers at the Merritt Island First Baptist Church. The church had a popular Vacation Bible School, and 125 children attended. They are standing in front of the educational building to the left, and the church itself is on the right.

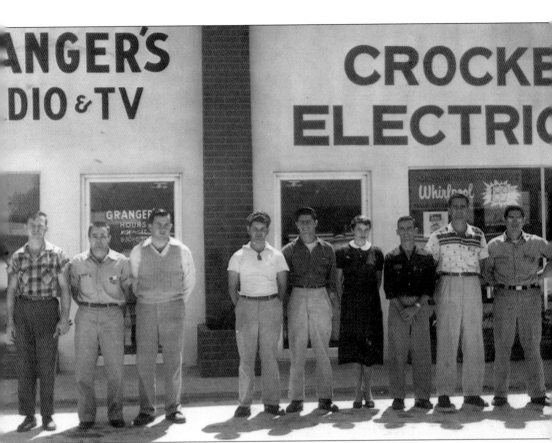

Two businesses located on Merritt Island are shown in this 1950s photograph. To the left was Granger's Radio and TV, and next door was Crockett Electric, which sold appliances. The sign in the window to the right advertises a "fully automatic" Whirlpool washer for $189. Included in the picture are Buster Jones, Leroy Lively, Jessie Granger, Leroy Granger, Charlie Spooner, Ima Jean Blankenship, and Perry Crockett.

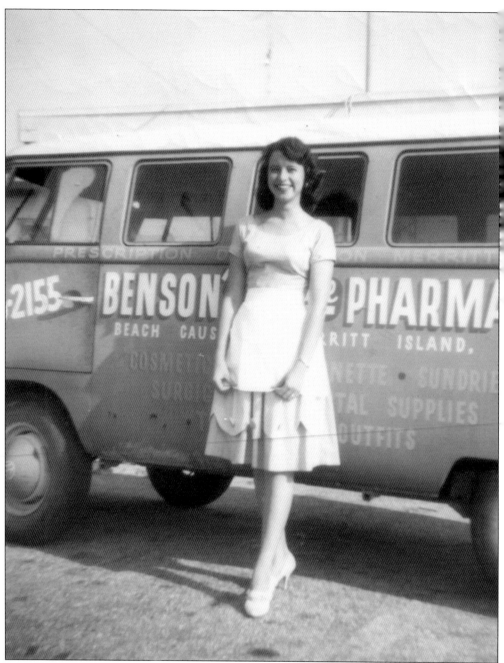

Merritt Island increased its residents and businesses during the space race, but it remains an unincorporated part of the Space Coast to this day. This photograph shows high school student Kathy Griffis Bishop, standing in front of a delivery van for Benson's Pharmacy, which was located at 91 East Merritt Island Causeway, in Merritt Island. The pharmacy and medicine supply was owned and operated by Marcellus Rambo Benson.

Six
Patrick Air Force Base

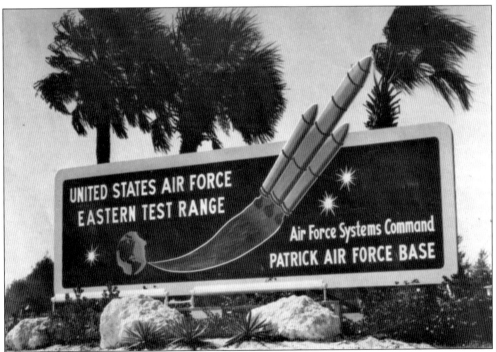

This 1960s sign, located on Highway A1A, welcomed visitors to Patrick Air Force Base and announced the U.S. Air Force Eastern Test Range, which was north of what is now Cape Canaveral. In 1947, the U.S. Air Force decided the area would be perfect for testing missiles.

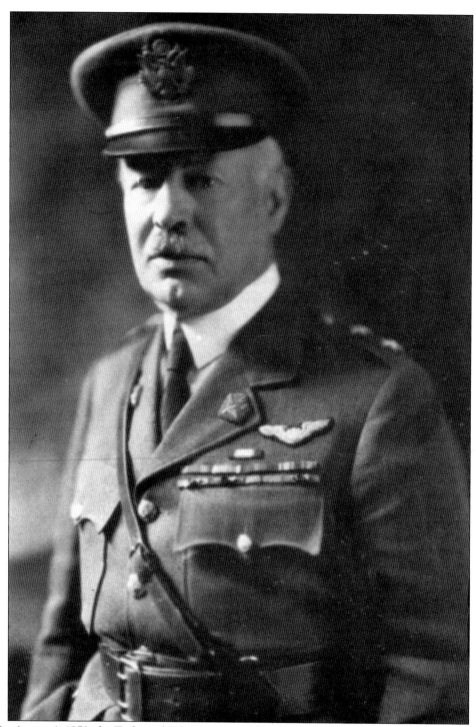

On August 1, 1950, the Technical Laboratory was officially renamed Patrick Air Force Base after Gen. Mason M. Patrick, pictured here. Patrick was the chief of the Air Service for the U.S. Army from 1921 to 1927. The base is south of Cocoa Beach and today is the home of the 45th Space Wing and the 920th Rescue Wing, two units involved with space launches.

The photograph above, probably taken in the 1950s, shows one of the main buildings on Patrick Air Force Base. In front of the building, which sits on Highway A1A to the south of Cocoa Beach, are several rockets developed by the U.S. Air Force. The 1960s photograph below shows the same building a few years later, with a mockup of an SM-62 Snark intercontinental cruise missile on display. The missile was operated by the U.S. Air Force from 1958 to 1961.

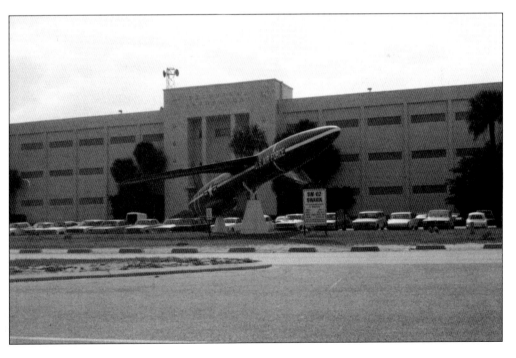

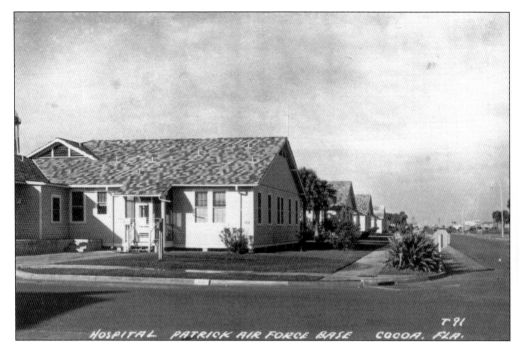

The photograph above shows the original hospital located on Patrick Air Force Base. The base was originally the Banana River Naval Air Station during World War II, but in 1950, it was put in use by the U.S. Air Force and was also called the Joint Long Range Proving Grounds. The postcard below shows a guard at the base gate. It was advertised as "The Guided Missile Base." The base was involved in guided missile development before the forming of NASA in 1958. Located between the Atlantic Ocean and the Banana River, the base is today the home of the 45th Space Wing.

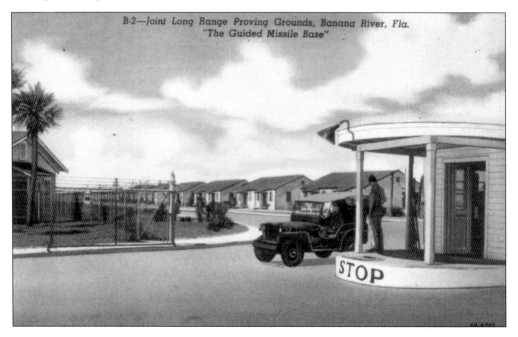

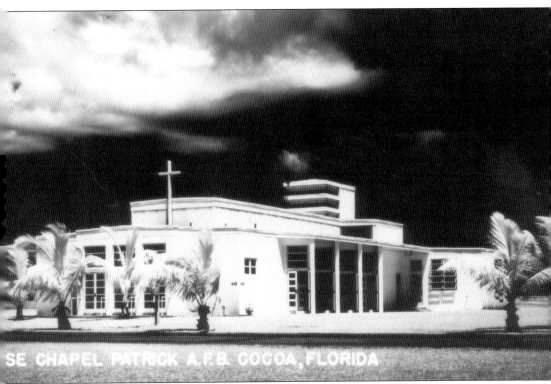

This photograph shows the base chapel at Patrick Air Force Base, Florida. The base chapel, like many on U.S. military installations, serves denominations of all kinds in the same building. The chapel was built to serve all military members and their families who are stationed at the base. Most military chaplains wear a uniform and hold an officer's rank.

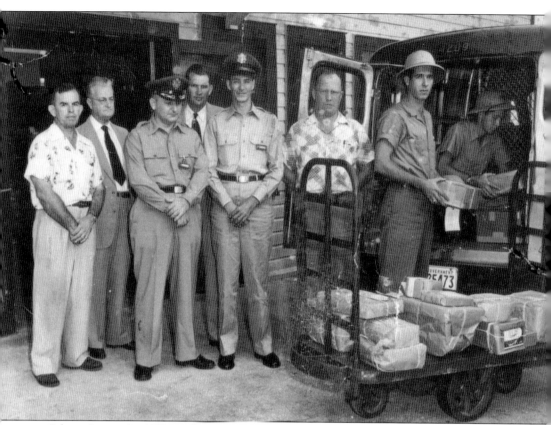

Like today, in the 1950s, military members and their families lived on Patrick Air Force Base in government-provided housing. This October 19, 1953, photograph shows the first day of home mail delivery on the base. Pictured are Oliver Haistens, Albert E. Booth, Colonel Adams, Ivan Townsend, Lieutenant Tully, Carol Booth, Gene Baird, and Fred McCabe.

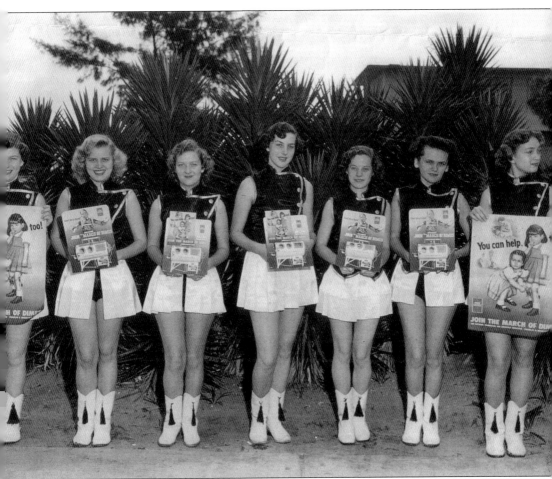

This 1952 photograph shows a March of Dimes charity drive held at Patrick Air Force Base. Pictured are Pat Blackmon, Earline Joiner, Barbara Horne, Ginger Harrell, Susie Scott, Mary Weathers, and Judy McCurry.

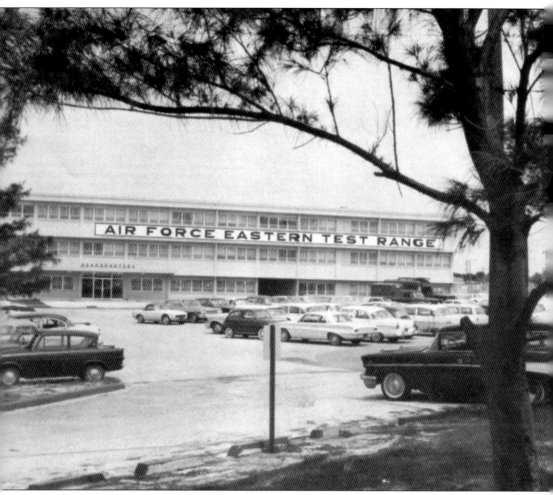

This is a 1960s view of the Air Force Eastern Test Range headquarters building located at Patrick Air Force Base. After the U.S. Air Force was given primary development responsibilities for long-range missiles, the base was the central point for their research. Cape Canaveral, just 15 miles away, was perfect for launches.

Seven
THE SPACE RACE

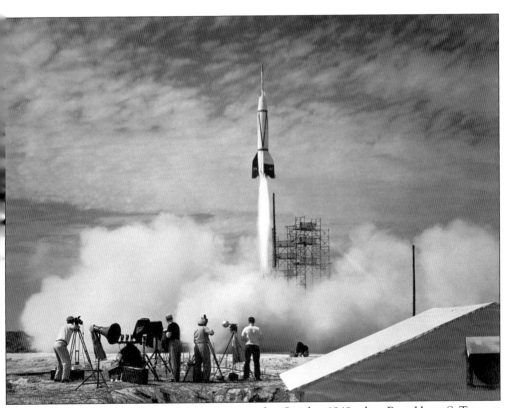

Brevard County entered the era of the space race after October 1949, when Pres. Harry S. Truman established the Joint Long Range Proving Grounds at Cape Canaveral. The first launch from the cape on July 24, 1950, was of a modified German Bumper V-2 rocket. The rocket flew 10 miles in altitude.

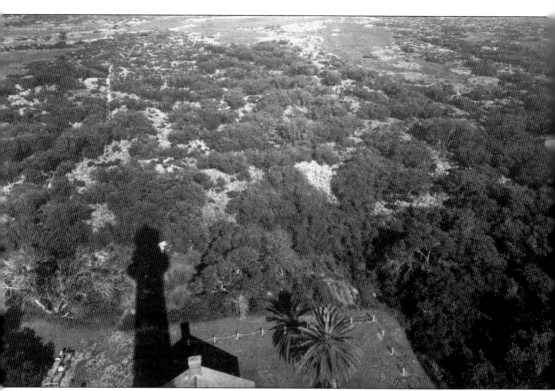

This photograph, taken in 1950 before the space race took off, shows the view of Cape Canaveral as seen from the top of the Cape Canaveral lighthouse. Note the shadow of the lighthouse at the bottom of the photograph. This lighthouse was built in the late 1800s, after a 60-foot-tall lighthouse was erected in 1848, but it proved too weak to help sea navigation.

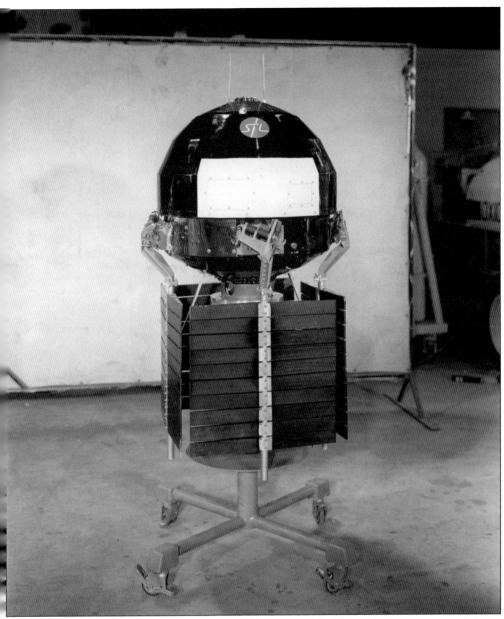

Pres. Dwight D. Eisenhower signed a law officially creating the National Aeronautics and Space Administration on July 29, 1958. Although NASA was not officially created until then, the government was continually testing rockets during the 1950s. In 1958, *Explorer 1* was launched from Cape Canaveral, and the United States became part of the space age. The 1959 photograph below shows the later launched *Explorer* 6 satellite.

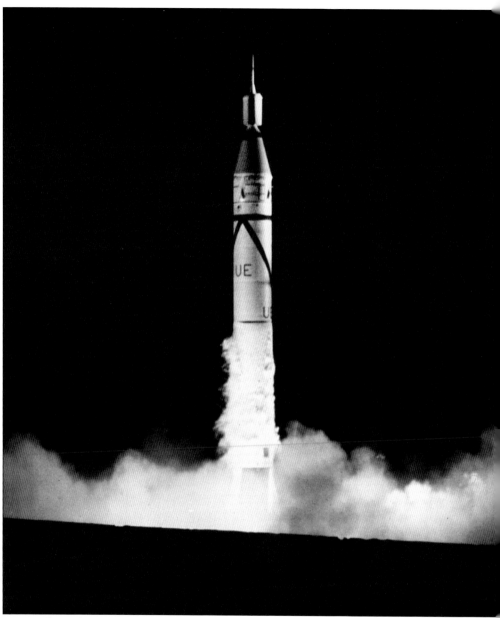

During the early space launch days, before manned flights, the U.S. Air Force and NASA were continually launching rockets of all kinds. This photograph taken in the early 1960s shows a launch of one of many Explorer satellites from Cape Canaveral.

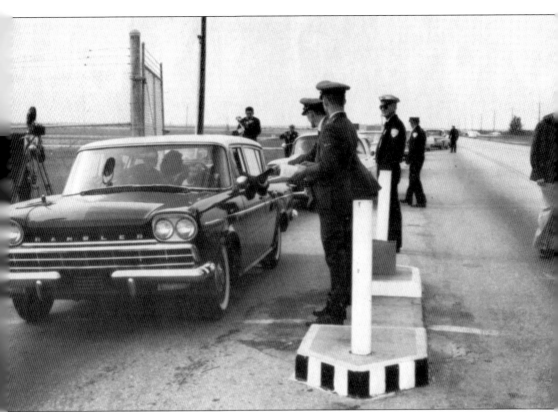

This 1960s photograph shows a Cape Canaveral Air Force Station gate while cars come in filled with tourists to see the launch facilities. U.S. Air Force members welcome the visitors. Millions of people would travel to Florida's Space Coast between the late 1950s and early 1970s to watch launches into space. Today most tours are done by bus, and the security at the facility is handled by a private contractor.

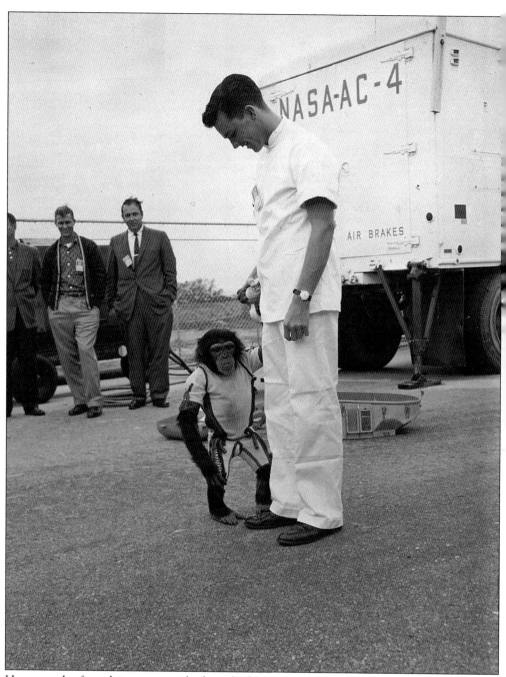

Ham was the first chimpanzee to be launched into space. Here he is being shown off by his animal trainer in Cape Canaveral. On January 31, 1961, Ham rode on a Mercury-Redstone 2 rocket and was successfully returned to Earth. Although monkeys had been launched into space before, the chimpanzee was the first higher primate to ride in a spacecraft. NASA engineers at the time considered the use of primates to be valuable in ensuring that future manned launches would be safe.

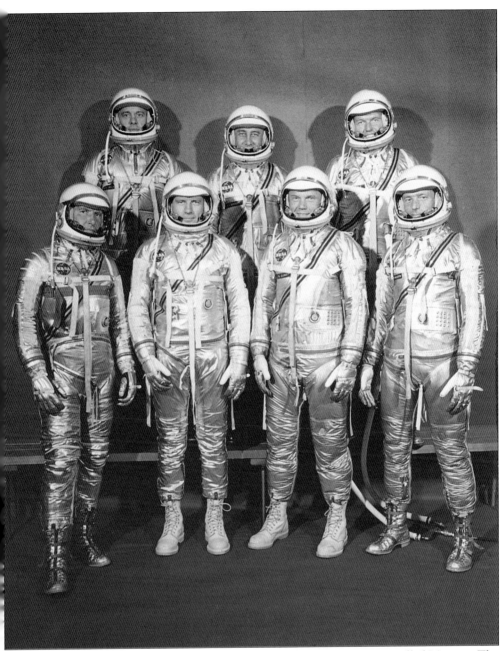

Out of 110 test pilots, seven were chosen for America's first space program, called Mercury. The selection was announced on April 9, 1959. These astronauts became known as the Original Seven, and many books, movies, and television shows have been made about their experiences. Pictured are (first row) Walter M. Schirra Jr., Donald "Deke" Slayton, John H. Glenn Jr., and Scott Carpenter; (second row) Alan B. Shepard Jr., Virgil "Gus" Grissom, and Gordon "Gordo" Cooper.

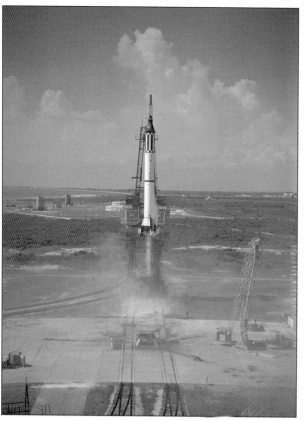

On April 12, 1961, Yuri Gagarin, a Soviet cosmonaut, became the first person to be launched into space. The space race was launched into high gear. Critics of America's space program wondered if NASA should have sent a man into space instead of using chimpanzees. On May 5, 1961, Alan B. Shepard Jr., part of the Mercury space program, became the first American in space. His historic flight took place on a Redstone rocket and flew him to an altitude of 116 statute miles. The above photograph shows the launch of *Freedom 7*, a Mercury-Redstone rocket, carrying Shepard on his launch into space. The photograph below Shepard as he is hoisted aboard a U.S. Marine Corps helicopter after a successful flight and splashdown of his Mercury space capsule.

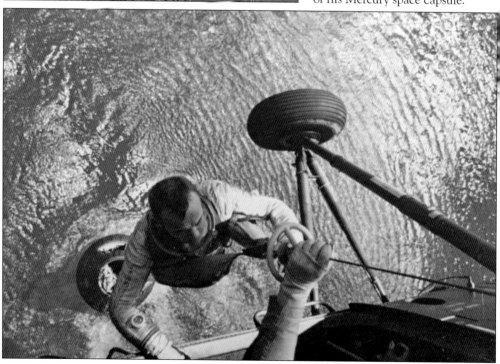

On July 21, 1961, astronaut Virgil "Gus" Grissom piloted the *Liberty Bell 7*, a Mercury-Redstone rocket, to an altitude of 118 statute miles flying 5,310 miles an hour. He splashed down in the Atlantic Ocean, some 305 miles from Cape Canaveral. The flight lasted just 16 minutes. The photograph on the right shows Grissom, assisted by technicians, as he exits his Mercury spacecraft following a flight simulation. The photograph below shows the successful launch from Pad 5 in Cape Canaveral. Grissom piloted the nation's second successful flight into space, and millions watched the launch on television.

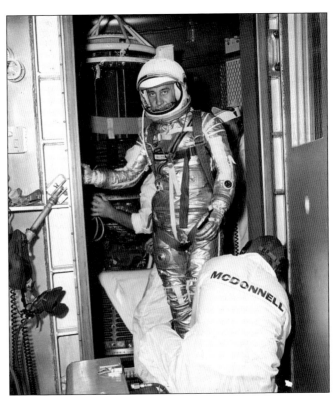

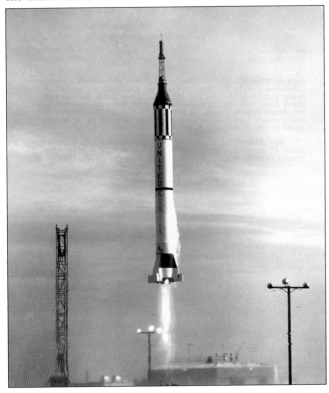

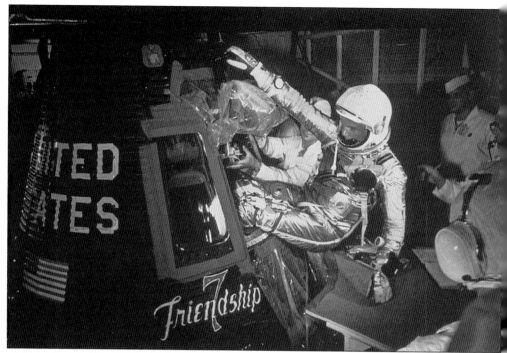

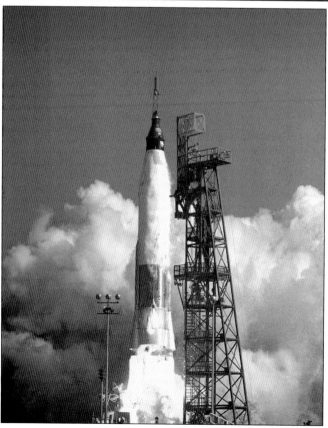

On February 20, 1962, astronaut John Glenn was thrust into space aboard a Mercury-Atlas 6 rocket, better known as *Friendship 7*. Glenn was the first astronaut to orbit Earth, circling the planet three times during a flight that lasted almost five hours. An emergency occurred during the mission when NASA engineers thought that Glenn's heat shield might have failed. Without his heat shield, Glenn and his spacecraft would burn up when reentering the Earth's atmosphere. After a successful splashdown, the astronaut was a national hero. The above photograph shows Glenn as he enters the *Friendship 7* spacecraft. The image below shows the successful launch of *Friendship 7* from Cape Canaveral.

The photograph on the right shows astronaut Scott Carpenter in 1962 at Cape Canaveral. Carpenter is working inside a hangar in what was called the White Room Facility, where he is inspecting the main pressure bulkhead or heat shield of the spacecraft he nicknamed "Aurora 7." On May 24, 1962, Carpenter was launched into space aboard a Mercury-Atlas 7 rocket and became the second person to orbit the Earth. His flight lasted about five hours. The photograph below shows Carpenter's rocket before it lifts off from Pad 14 in Cape Canaveral. One interesting bit of trivia about the flight was that astronaut Deke Slayton was originally scheduled to fly it, but he had to be replaced because of a heart condition. Carpenter, as the backup pilot for John Glenn, was perfect for the job.

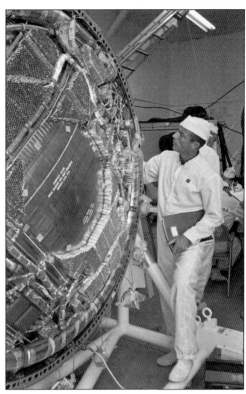

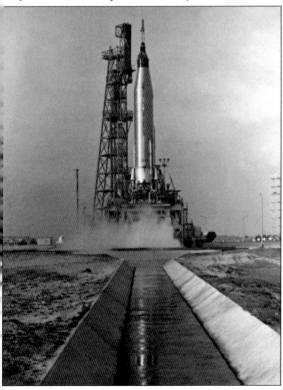

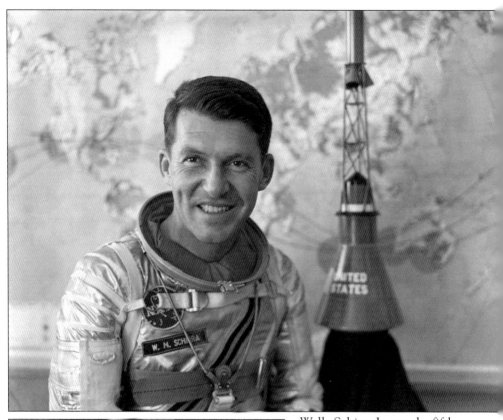

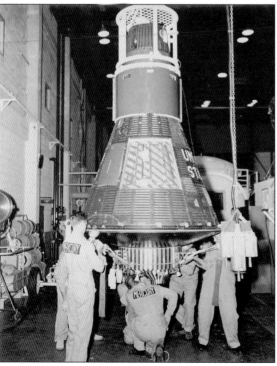

Wally Schirra Jr. was the fifth American in space, and not only was he one of the original Mercury Seven astronauts, but he was the only person to go into space for NASA's first three space programs. He called his Mercury spacecraft "Sigma 7," and on October 3, 1962, Schirra flew from Cape Canaveral on a nine-hour mission that took him around the Earth six times. The photograph below shows technicians at a hangar in Cape Canaveral as they prepare *Sigma 7* for delivery to the launch pad before its launch. Once delivered to the pad, the capsule would be mated to an Atlas rocket.

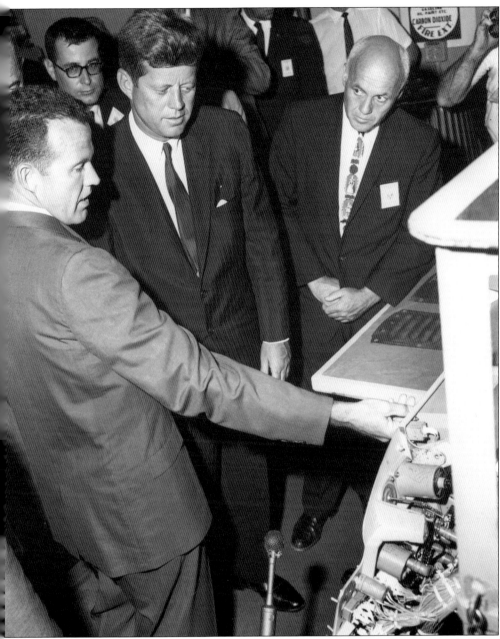

In 1962, Pres. John F. Kennedy toured the NASA facilities located at Cape Canaveral. Along the tour with him was astronaut Gordon "Gordo" Cooper. Just one year before, the president had announced a new mission for the agency, one that drew the attention of the entire world. On May 25, 1961, he gave a speech saying that the United States "should commit itself to achieving the goal, before this decade is out, of landing a man on the Moon and returning him back safely to the Earth."

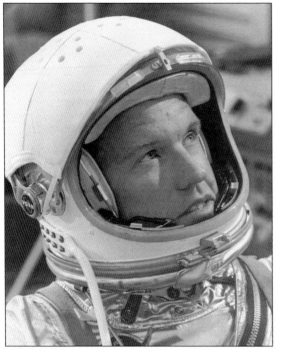

On May 15, 1963, astronaut Gordon "Gordo" Cooper was launched into space from a launch pad in Cape Canaveral. He was the last person to fly into space with the Mercury space program. At that time, he flew farther and faster than anyone before him. Cooper's flight took him on 22 orbits. With over 34 hours of time in space, and he logged more time than all of the previous Mercury astronauts combined. He flew 17,547 miles per hour and was the first astronaut to sleep in space. The photograph above shows Cooper in his space pressure suit and helmet as tests are done in preparation for his launch into space. The photograph below shows NASA technicians in Cape Canaveral as they track astronaut Gordon Cooper's historic flight into space.

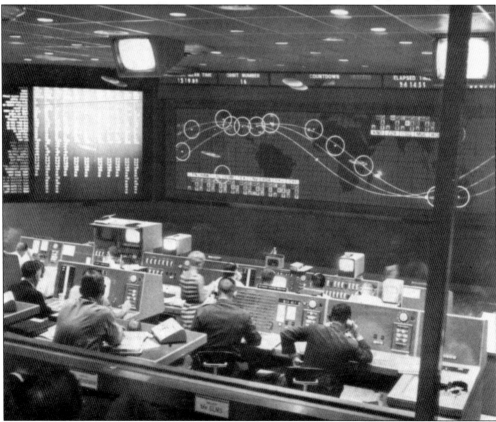

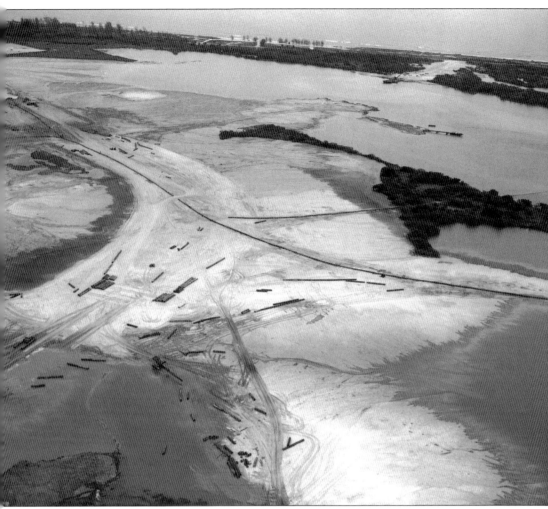

Between the end of the Mercury program in 1962 and the beginning of the Gemini program in 1965, NASA continued its growth through congressional funding in the onward push to send men to the moon. This aerial photograph, taken on January 1, 1963, shows the construction of Launch Complex 39A and the dredging of water to facilitate a crawler way at what is now Kennedy Space Center. Once it was built, a crawler vehicle would carry rockets to the new pad in preparation for launch.

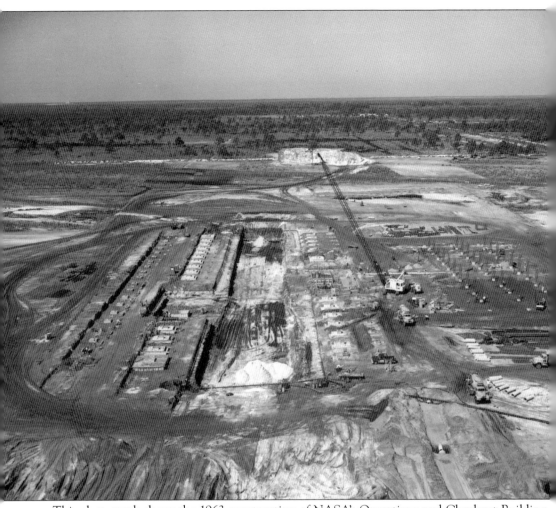

This photograph shows the 1963 construction of NASA's Operations and Checkout Building and the Manned Spacecraft Operations Building at Kennedy Space Center. All of the Gemini and Apollo modules were tested in these buildings.

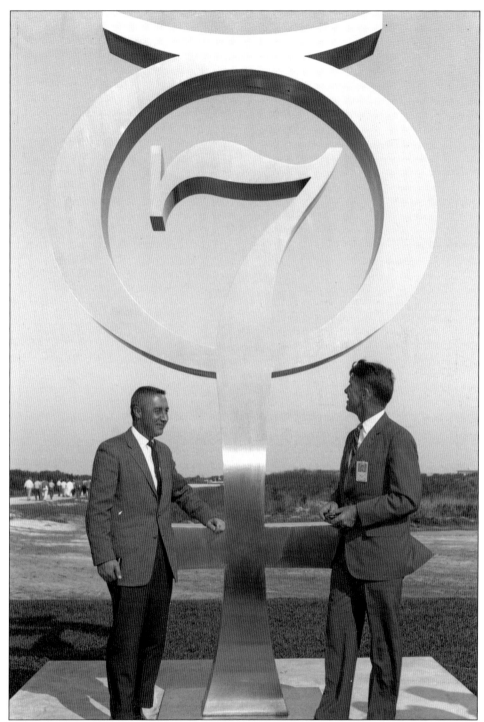

In 1964, the Mercury Monument was dedicated outside of Complex 14 in Cape Canaveral. The number seven, which stands for the original seven Mercury astronauts, is placed inside the astronomical symbol of the planet Mercury. This photograph shows astronauts Virgil "Gus" Grissom and Wally Schirra at the dedication of the monument.

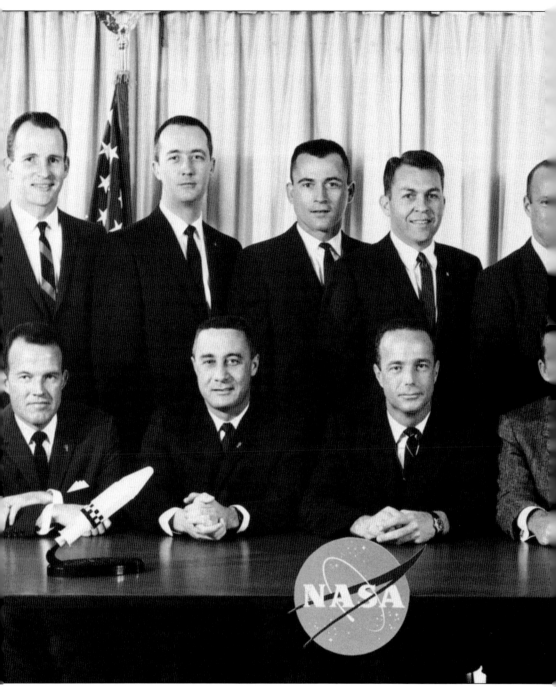

A second group of astronauts was named in 1962, as NASA was preparing for the upcoming Gemini program. The new program would be an intermediary step between the Mercury and Apollo programs. Mercury had proved that NASA could put men into space and return them safely to Earth. Gemini would go further, adding a second crew member to launches and the ability to maneuver spacecraft, among many other things. Pictured are the original seven astronauts and

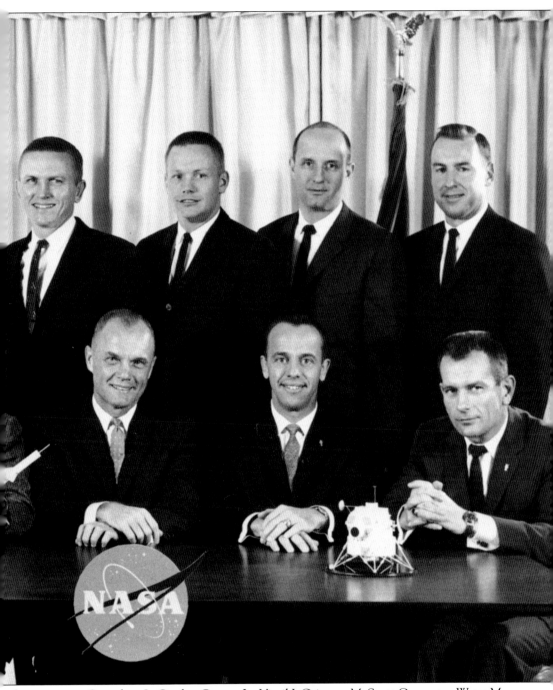

the new group. Seated are L. Gordon Cooper Jr., Virgil I. Grissom, M. Scott Carpenter, Water M. Schirra Jr., John H. Glenn Jr., Alan B. Shepard Jr., and Donald K. Slayton. The new astronauts (standing) are Edward H. White II, James A. McDivitt, John W. Young, Elliot M. See Jr., Charles Conrad Jr., Frank Borman, Neil A. Armstrong, Thomas P. Stafford, and James A. Lovell Jr.

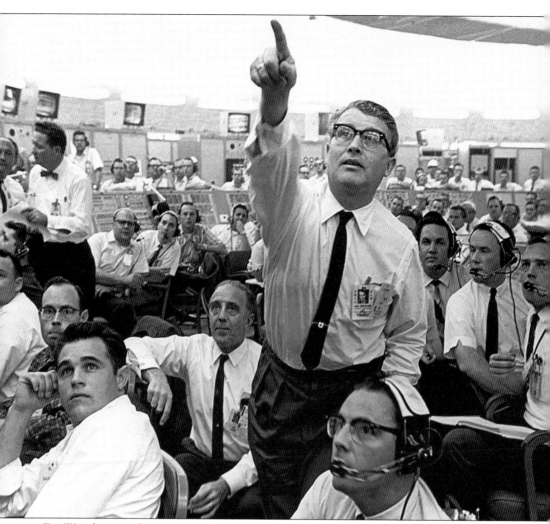

Dr. Wernher von Braun was a physicist and engineer who was instrumental in the success of the U.S. space program. This photograph, taken in 1965, shows von Braun during the Saturn I rocket launch, pointing to a television screen in a Saturn blockhouse at Cape Canaveral. The blockhouses were reinforced concrete structures used for observing launches. The rocket carried a satellite into orbit.

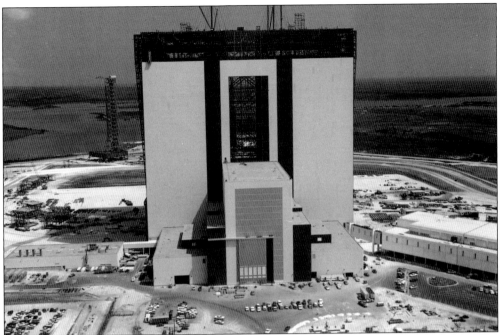

The 1965 photograph above shows the Vehicle Assembly Building (VAB) under construction at Kennedy Space Center. The building would be used to assemble the huge Saturn V rockets, which were 60 feet taller than the Statue of Liberty. The VAB is 525 feet tall, 716 feet long, and 518 feet wide. It covers 8 acres of land. Due to its vast size, the building requires the use of a moisture reduction system in order to avoid the formation of clouds on the inside. The building is still used today for the Space Shuttle program and will probably be used in the next generation of space vehicles as well. The photograph below shows Dr. Kurt H. Debus, the first director of Kennedy Space Center, making a brief speech during a topping-off ceremony on April 14, 1965, in front of the VAB.

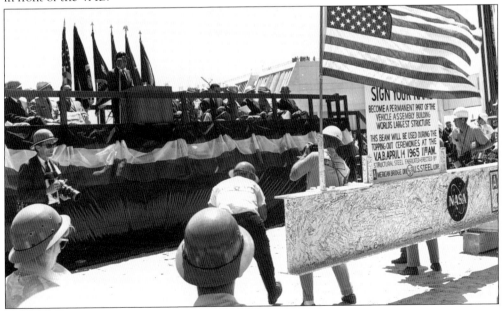

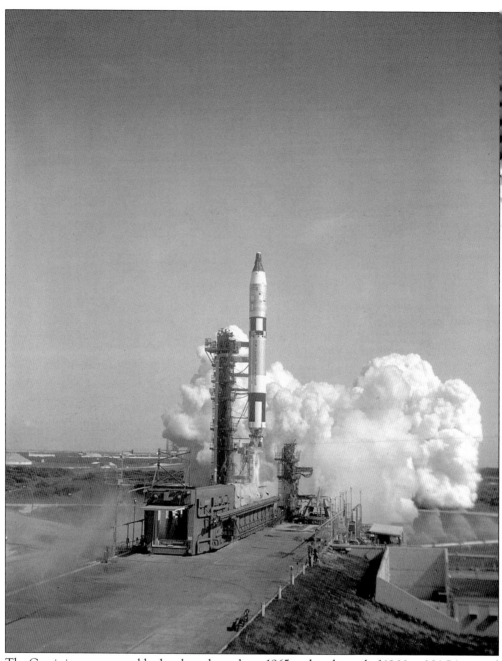

The Gemini program would take place throughout 1965 and to the end of 1966, as NASA moved quickly toward the goal of placing a man on the moon. The first manned flight in the Gemini space program took place in March 1965. Later that year on August 21, NASA launched the *Gemini 5* spacecraft with astronauts Gordon Cooper and Charles Conrad, as seen in this photograph.

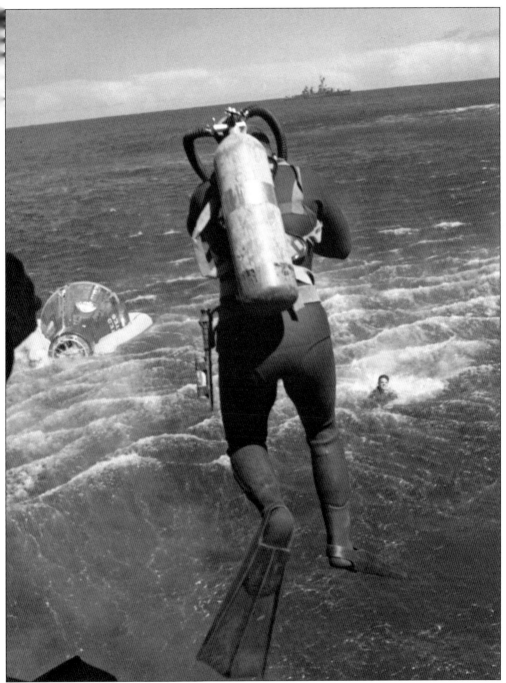

A navy diver in this 1965 photograph exits a helicopter to help recover the *Gemini 5* astronauts and their space capsule after a successful splashdown. The mission was the 11th manned NASA flight and lasted eight days. The crew consisted of astronauts Gordon Cooper and Charles Conrad, and the flight completed 120 orbits around the Earth.

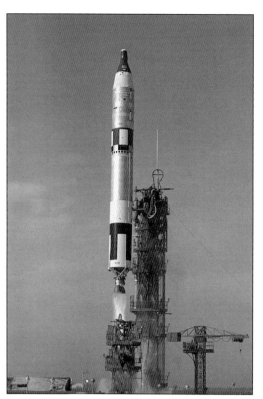

The December 15, 1965, photograph above shows the *Gemini* 6 Titan rocket launching from Cape Canaveral. The crew consisted of astronauts Walter Schirra and Thomas Stafford. The mission was to rendezvous with *Gemini* 7, also in orbit. The photograph below shows astronauts Schirra and Stafford as they go through suiting up exercises in preparation for the *Gemini* 6 flight in October 1965.

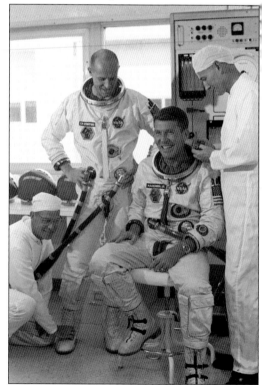

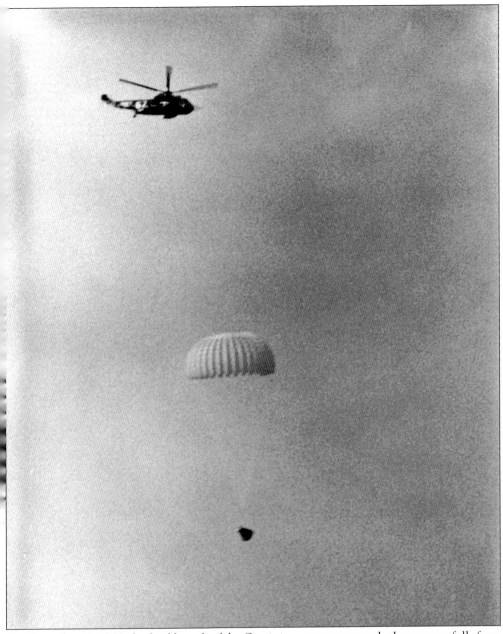

On November 11, 1966, the final launch of the Gemini space program took place successfully from Cape Canaveral. Astronauts Jim Lovell and Edwin "Buzz" Aldrin stayed in space for almost four days after rocketing into orbit on their *Gemini 12* Titan rocket, the 10th manned Gemini flight. A critical mission objective was completed when Aldrin set a record for extravehicular activity, or EVA, by completing a five hour and 30 minute space walk. The preparation for Aldrin's space walk included underwater training, which was used for the first time. It is still used for space walk simulation today. The astronauts also performed a rendezvous and docking with another space vehicle, and then the capsule's reentry was successfully controlled by computer. The photograph shows a helicopter hovering above the *Gemini 12* spacecraft as it descends to the Atlantic Ocean with parachute open.

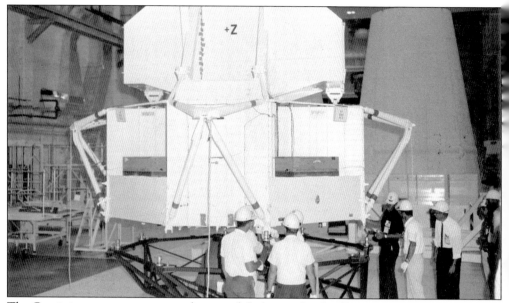

The Gemini program was over, and manned flights in the Apollo program would begin soon. A fact not widely understood, though, is that the Apollo program had been ongoing since the beginning of the decade. Unmanned missions were used to test various Saturn booster rockets and primary systems that were needed to get astronauts to the moon. The above photograph shows a lunar module simulator that was used in preparations for the *Apollo 5* unmanned mission. The mission would feature the first flight of the Apollo Lunar Module. The photograph below shows Firing Room No. 1 at the Launch Complex 39 Launch Control Center. The firing room was used to monitor the launches of the Apollo Saturn V rockets from Cape Canaveral.

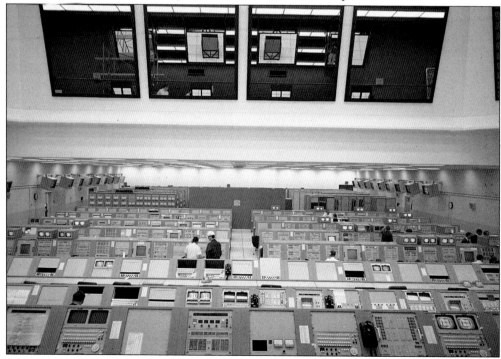

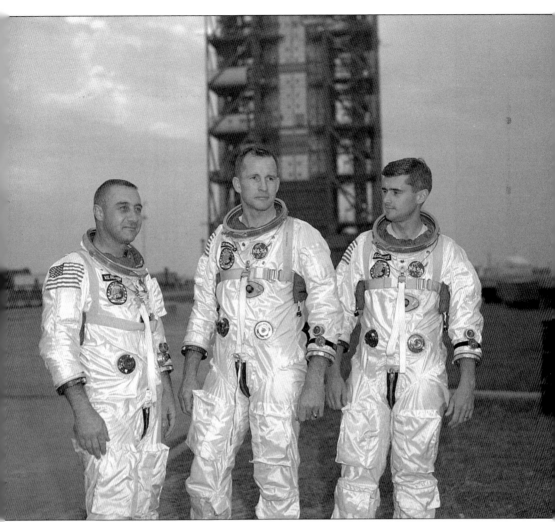

Throughout the Apollo program's history, there was only one major failure and one serious emergency in space. In this photograph, taken in January 1967, are *Apollo 1* astronauts Virgil "Gus" Grissom, Ed White, and Roger Chaffee, standing in front of Launch Complex 34. The astronauts were tragically killed on January 27, 1967, in an accidental fire that erupted as they sat in their capsule on the launch pad. The exact cause of the fire was never discovered, but it was attributed to several factors, including a 100-percent oxygen environment inside the capsule and a hatch door that only opened inward. After the accident, NASA engineers were forced to correct capsule design flaws and change operating procedures in order to make future astronauts safer. The tragedy would delay the Apollo program for more than a year.

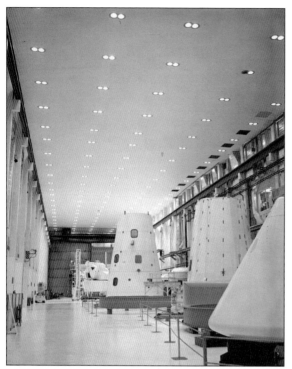

Budget estimates given to Congress in the late 1960s for NASA expenditures showed that up to $25 billion would be needed to finish the Apollo program. This is somewhere in the range of $135 billion if adjusted to what it would be today. Part of that money was spent on designing and building brand-new facilities at Kennedy Space Center. The above photograph, taken in March 1968, shows the inside of the now completed Operations and Checkout Building at Kennedy Space Center as various Apollo program modules are processed in the facility. The photograph below, also taken in 1968, shows a fisheye view looking down into the Vehicle Assembly Building, also located at the center. Both facilities were created to make the Apollo program a reality.

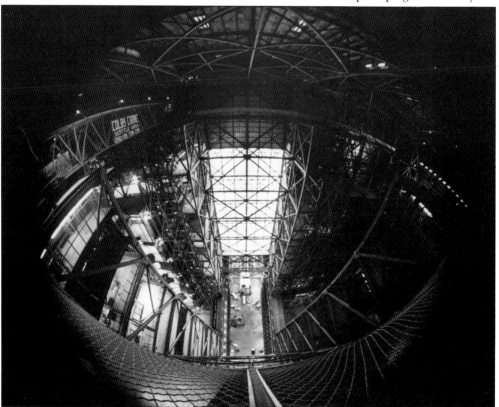

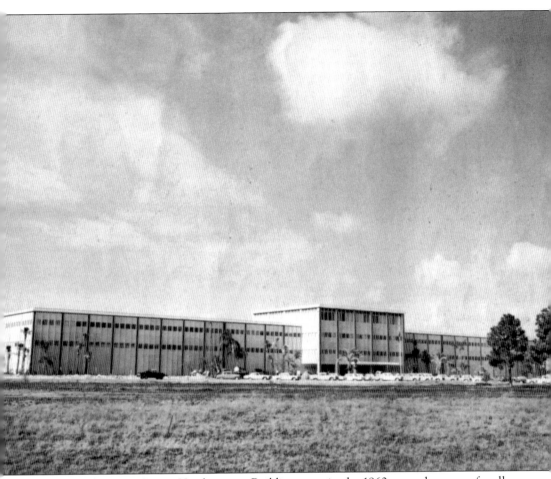

NASA's Kennedy Space Center Headquarters Building, seen in the 1960s, was the center for all administration and planning. The center is located north of Merritt Island and west of Cape Canaveral Air Force Station.

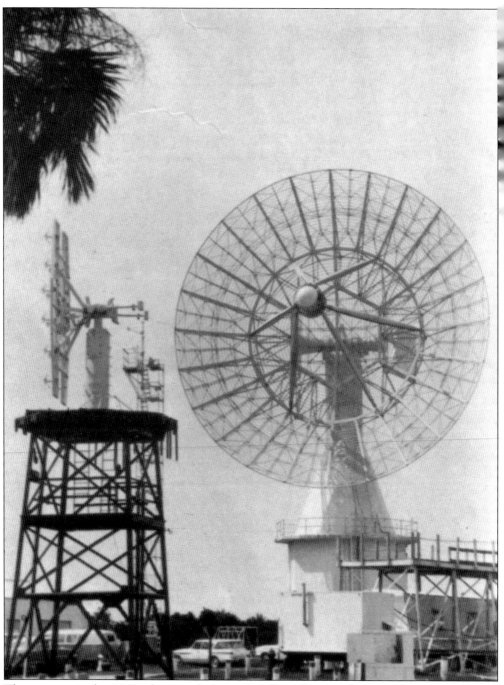

The antenna in this 1960s photograph, located in Cape Canaveral, was used to receive signals from rockets during flight. The data received allowed engineers to analyze many factors associated with the mission at hand.

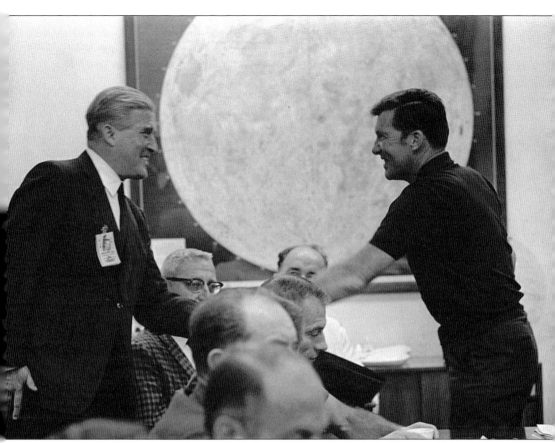

This photograph shows astronaut Walter M. Schirra as he greets Dr. Wernher Von Braun during a prelaunch mission briefing for *Apollo 7* at Kennedy Space Center. It would be the first manned mission in the Apollo program to be launched. Because of the *Apollo 1* accident, the flight was not only a test of engineering but a test of confidence for the space program and its astronauts.

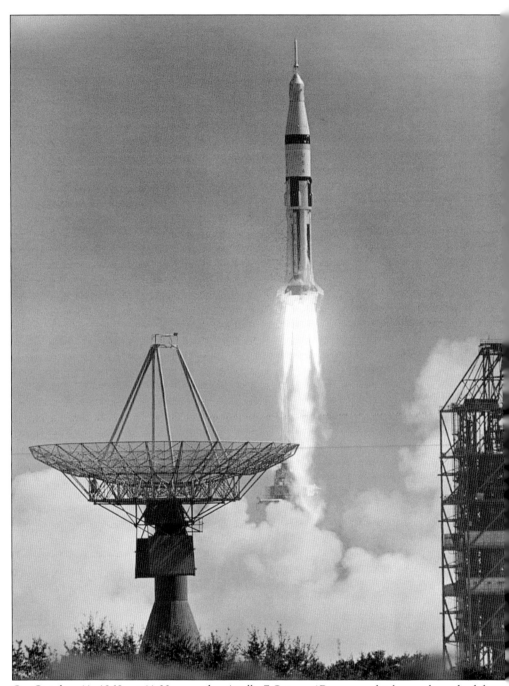

On October 11, 1968, at 11:03 a.m., the *Apollo 7* Saturn 1B space vehicle was launched from Kennedy Space Center at Launch Complex 34, as seen in the photograph. Since the *Apollo 1* accident, NASA engineers had redesigned the command module, many systems, and the astronaut's space suits. The 11-day mission would carry astronauts Walter M. Schirra, Donn F. Eisele, and R. Walter Cunningham on 163 orbits. All systems functioned like they were designed, and the only real problem was a head cold that bothered Schirra. The first live television broadcast occurred during the mission.

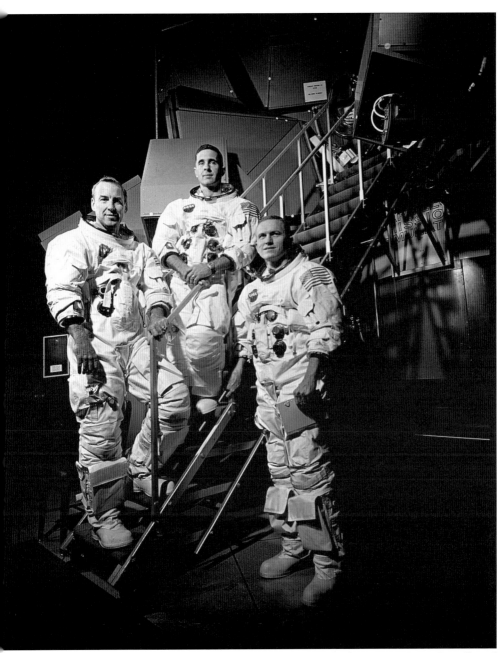

Apollo 8 launched on December 21, 1968, and took astronauts Frank Borman, James Lovell, and Williams Anders on 10 orbits around the moon. The mission for *Apollo 8* did not originally plan for them to orbit the moon, but it was ambitiously changed after the success of *Apollo 7*. The crew became the first humans to see the far side of the moon with their own eyes. The crew read the first 10 verses from the Book of Genesis, which was televised live around the world as the Earth came into view in the darkness of space. The event was watched by more people than any other television broadcast up until that time. This photograph, taken on November 11, 1968, shows Lovell, Anders, and Borman in their space suits while standing in front of a simulator at Kennedy Space Center.

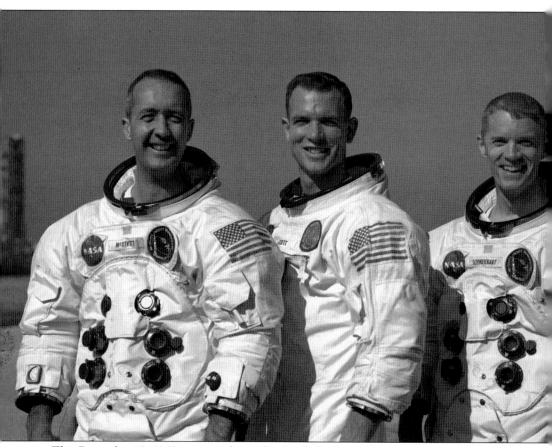

This December 18, 1968, portrait shows the *Apollo* 9 crew in their space suits at Kennedy Space Center. The astronauts are James A. McDivitt, David R. Scott, and Russell L. Schweickart. *Apollo* 9 launched on March 3, 1969, taking the crew on a 10-day low Earth orbital journey. It was the first test of the complete Apollo spacecraft.

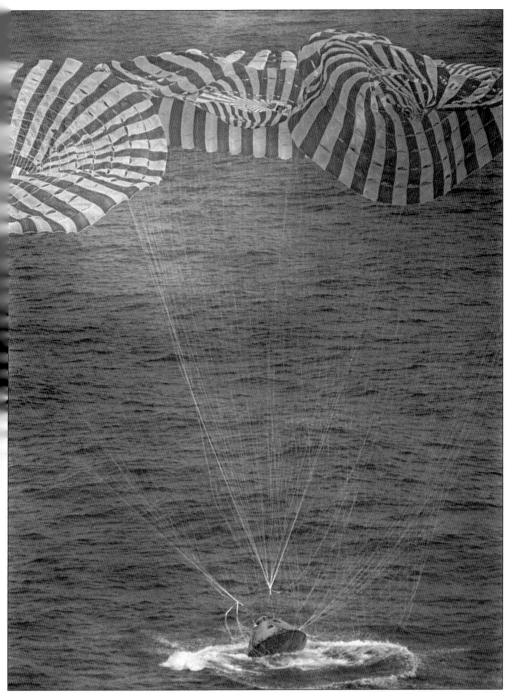

The *Apollo* 9 mission tested the Apollo Command and Lunar Modules while in Earth's orbit. During the tests, it was proved that the modules could dock together, and other important tests were completed using the lunar module. It was also the first docking ever of two manned spacecraft, and it was the first Apollo mission where the crew was allowed to name their own spacecraft. The photograph below shows the successful splashdown of the *Apollo* 9 crew in the Atlantic Ocean recovery area.

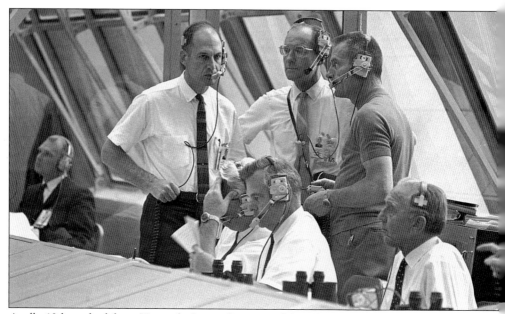

Apollo 10 launched from Kennedy Space Center on May 18, 1969, and was the fourth manned mission in the program. It was the second time a crew would orbit the moon and the first live color television broadcast from space. The above photograph, taken at Kennedy Space Center, shows *Apollo 10* mission engineers as they prepare for launch at the Launch Control Center Firing Room No. 3. The second photograph shows NASA officials and visitors as they watch the launch of *Apollo 10*. Included in the picture are the Kennedy Space Center deputy director for administration, Albert Siepert (seated at left on the third row), and Belgium's King Baudouin and Queen Fabiola. Next to the queen is Mrs. Siepert. Former vice president Hubert Humphrey is seen wearing a baseball cap at right while he talks with Mr. and Mrs. Emil Mosbacher.

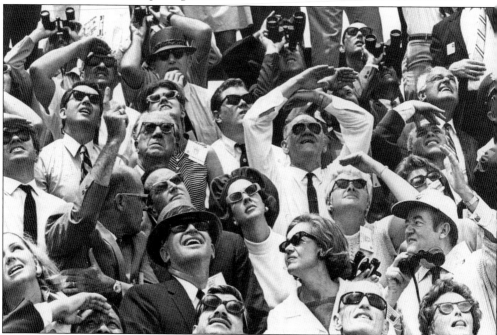

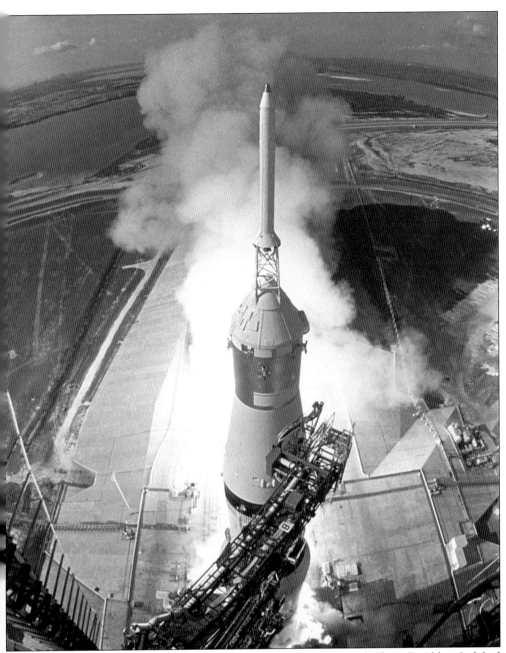

On July 16, 1969, astronauts Neil Armstrong Jr., Michael Collins, and Edwin E. Aldrin Jr. lifted off from Kennedy Space Center aboard *Apollo 11*. The goal was to fulfill the 1961 challenge as laid out by former president John F. Kennedy to land men on the moon and return them safely to Earth. The launch would send the crew into orbit; then another engine would push the rocket toward the moon. This photograph shows the Saturn V rocket as flame bursts out and it launches from Pad 39A at Kennedy Space Center.

Tens of thousands of people crowded the roads and beaches near Cape Canaveral to watch the *Apollo 11* Saturn V rocket launch, as seen in this photograph. Millions of people also watched the launch and the rest of the mission on television, which provided quite a show. It took three days for *Apollo 11* to enter the moon's orbit.

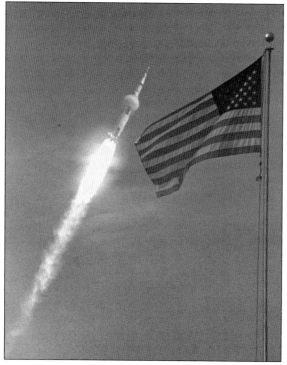

Behind an American flag at Kennedy Space Center on July 16, 1969, the *Apollo 11* Saturn V rocket approaches Mach 1 in this launch photograph. Astronauts Neil A. Armstrong, Michael Collins, and Edwin E. Aldrin Jr. were its crew, and they were about to enter history.

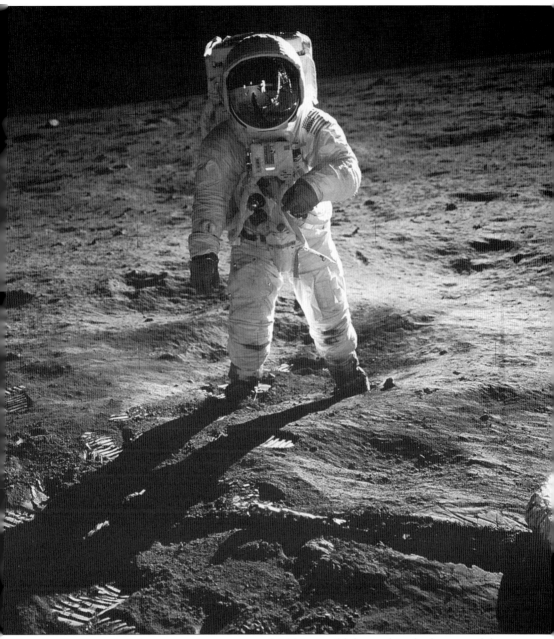

When *Apollo 11* reached the moon, Armstrong and Aldrin would descend in the lunar module to the moon's surface, while Collins remained in the orbiting Command Module. Armstrong would be the first man to set foot on the moon, saying, "One small step for man, one giant leap for mankind" as his foot touched the lunar surface. This photograph taken on July 20, 1969, shows Aldrin as he walks on the surface of the moon. The men would return to Earth safely on July 24.

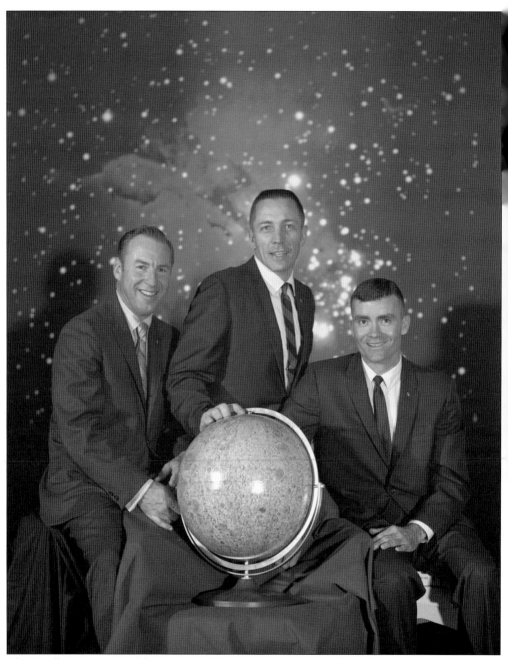

The Apollo program would continue with missions 12 through 17, and three later missions were cancelled because of funding being redirected for the upcoming Space Shuttle program. After *Apollo 11*, *Apollo 13* was the most famous because of an emergency caused by an in-space explosion. The picture shows *Apollo 13* astronauts James A. Lovell, John L. Swigert Jr., and Fred W. Haise Jr. at Kennedy Space Center.

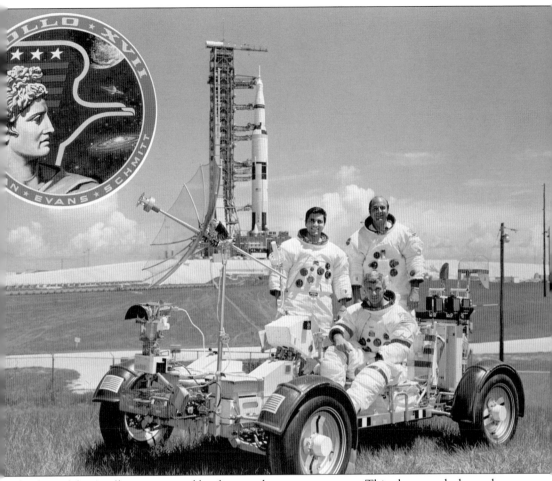

The days of the Apollo missions and landing on the moon were over. This photograph shows the *Apollo 17* crew and their mission patch at Kennedy Space Center in 1971. Pictured are astronauts Eugene A. Cernan, Ronald E. Evans, and Harrison H. Schmitt. The crew launched on December 7, 1972, on the final mission to put men on the moon. The end of the Apollo missions was a major factor that caused a decrease in the Florida Space Coast's population for the first time in two decades.

www.arcadiapublishing.com

Discover books about the town where you grew up, the cities where your friends and families live, the town where your parents met, or even that retirement spot you've been dreaming about. Our Web site provides history lovers with exclusive deals, advanced notification about new titles, e-mail alerts of author events, and much more.

Arcadia Publishing, the leading local history publisher in the United States, is committed to making history accessible and meaningful through publishing books that celebrate and preserve the heritage of America's people and places. Consistent with our mission to preserve history on a local level, this book was printed in South Carolina on American-made paper and manufactured entirely in the United States.

This book carries the accredited Forest Stewardship Council (FSC) label and is printed on 100 percent FSC-certified paper. Products carrying the FSC label are independently certified to assure consumers that they come from forests that are managed to meet the social, economic, and ecological needs of present and future generations.

Find Your Place in History.